Makishi

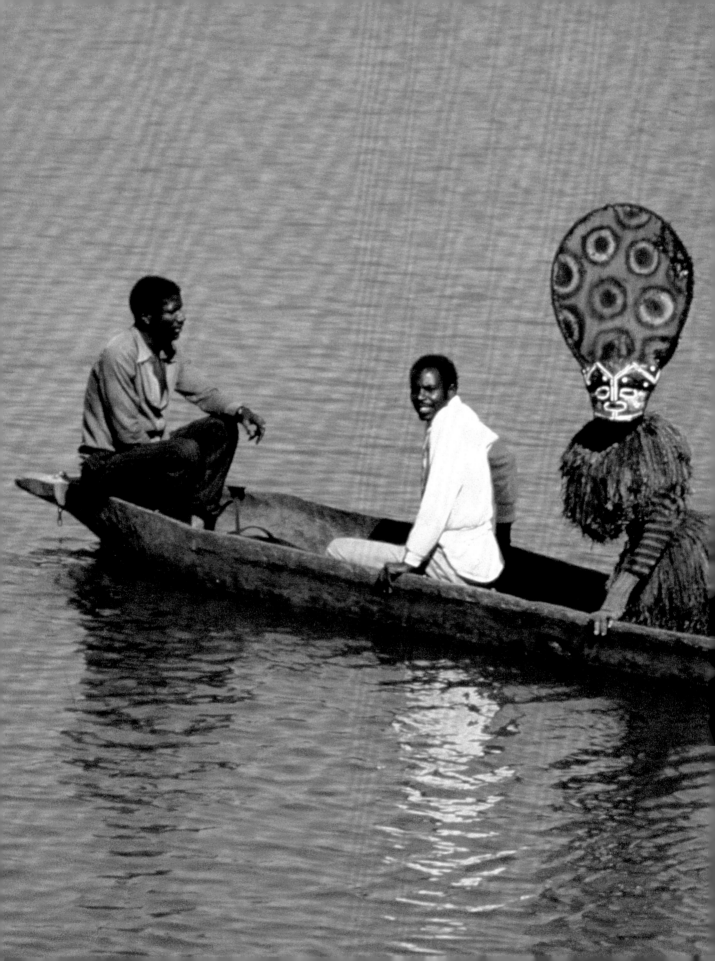

Makishi

Mask Characters of Zambia

Manuel Jordán

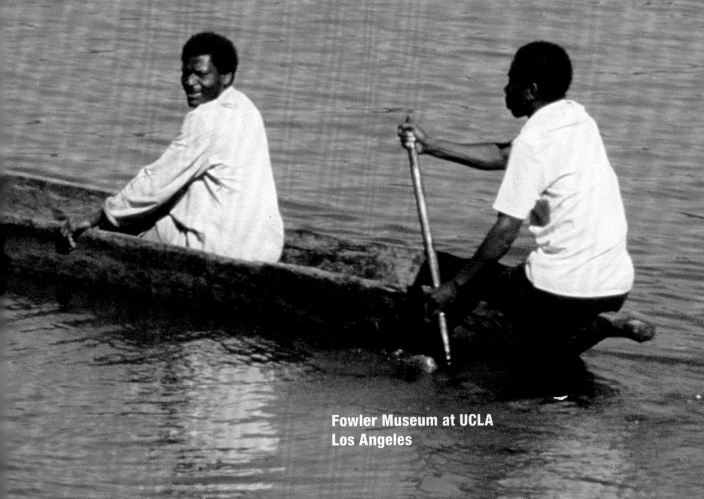

Fowler Museum at UCLA
Los Angeles

Makishi collection purchased with funds provided by

Jay and Deborah Last

Major funding for this publication has been provided by

National Endowment for the Arts
Manus, the support group of the Fowler Museum at UCLA

NATIONAL
ENDOWMENT
FOR THE ARTS

The Fowler Museum is part of UCLA's School of the Arts and Architecture

Lynne Kostman, *Managing Editor*
Danny Brauer, *Designer and Production Manager*
Don Cole, *Principal Photographer*
David L. Fuller, *Cartographer*

Fowler Museum at UCLA
Box 951549
Los Angeles, California 90095-1549

Requests for permission to reproduce material from this volume should be sent to the Fowler Museum Publications Department at the above address.

Printed and bound in Hong Kong by South Sea International Press, Ltd.

Library of Congress Cataloging-in-Publication Data

Jordán, Manuel.
 Makishi : mask characters of Zambia / Manuel Jordán.
 p. cm.
 Includes bibliographical references and index.
 ISBN-13: 978-0-9748729-7-1 (soft cover)
 ISBN-10: 0-9748729-7-0 (soft cover)
1. Masks—Zambia. 2. Rites and ceremonies—Zambia. I. Title.
 GN657.R4J67 2006
 306.4096894—dc22

 2006011667

Front cover: Detail, Cat. no. 2.
Back cover: See fig. 3.8.

FOWLER IN FOCUS

Makishi is a Fowler in Focus book.

Contents

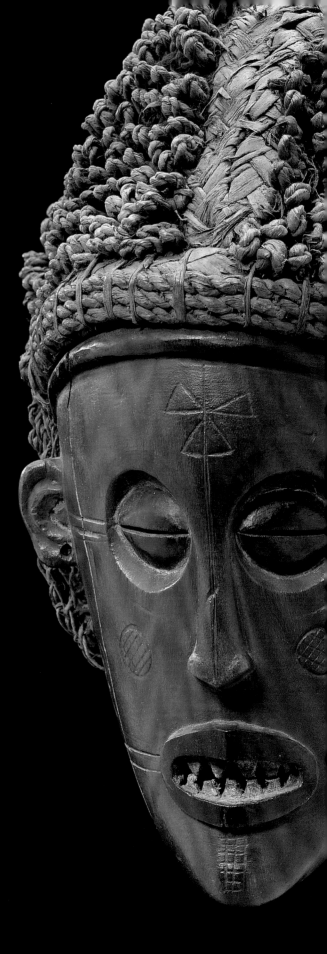

Foreword

Until quite recently, little was known about the remarkable masquerades of a constellation of ethnic groups in the "Three Corners" region of northwestern Zambia, northeastern Angola, and southwestern Democratic Republic of the Congo (DRC)—an area of central Africa where a number of peoples reside in close proximity, their styles and traditions overlapping yet distinct. The only well-known style among them was Chokwe, while the ethnic names Mbunda, Lunda, Luvale/ Lwena, and Luchazi were, and still are, relatively unfamiliar in African art scholarship. Moreover, few of the art forms of these peoples were to be found in museum or private collections.

Makishi: Mask Characters of Zambia and the exhibition that accompanies it constitute the second entry in the Fowler Museum's "Fowler in Focus" installation series, a component of the Museum's new long-term exhibition initiative, *Intersections: World Arts, Local Lives*. "Fowler in Focus" exhibitions rotate on a regular basis to highlight important subcollections and donations to the Museum's permanent holdings. The present volume and exhibition celebrate twenty outstanding masks recently acquired through the generosity and commitment of Jay and Deborah Last. Jay Last's keen eye and appreciation of the serial image have resulted in a number of extraordinary donations to the Fowler that enable scholars and visitors alike to consider variations within a single genre and the innovations of individual artists given otherwise enduring formal principles. We warmly thank Jay for bringing our attention to this remarkable corpus of Zambian works assembled by Belgian scholar Marc Leo Felix. We also wish to express our gratitude to Marc Felix for emphasizing the research value of these masks and the importance of having them enter a museum as a group for comparative study.

The addition of these twenty masks to the Fowler's African collections is nothing short of momentous. Although the Fowler is fortunate to possess one of the most important African collections in the world, these new Zambian works fill a gap in its central African holdings. It is rare to acquire a collection of such breadth and depth from a single region. That we now have a far more thorough understanding of the contexts, uses, and meanings of these masks than we would have had ten years ago and that we are gaining a far deeper understanding of the art styles of the "Three Corners" region is largely the result of the innovative research, publishing, and exhibitions of Manuel Jordán, author of the present volume and Phyllis Wattis Curator of the Arts of Africa, Oceania, and the Americas at the Iris & B. Gerald Cantor Center for the Visual Arts at Stanford University.

Manuel completed his dissertation in art history, "Tossing Life in a Basket: Art and Divination among Chokwe, Lunda, Luvale, and Related Peoples of Northwestern Zambia," at the University of Iowa in 1996. This study explored and elucidated the complex inner workings of one of the most fascinating of African divination techniques and provided intricate understandings of the fluidity of ethnic realities in this region of Africa. The constant exchange of ideas, people, and things across cultural boundaries and the continual shifting and reshaping of ethnic identities are indicative of an Africa that is in constant movement.

In 1998, as curator of the arts of Africa and the Americas at the Birmingham Museum of Art in Alabama, Jordán conceived and curated a landmark interdisciplinary exhibition program and accompanying book entitled *Chokwe! Art and Initiation among Chokwe and Related Peoples*. The exhibition was a richly beautiful cross-cultural exploration of art, initiation, and masquerade, complemented by a collection of essays by prominent scholars. Traveling to several venues, *Chokwe!* was widely acclaimed for its creative approaches to its subject matter. Following this,

Jordán co-authored with Marc Leo Felix a beautifully illustrated book on Zambian masks entitled *Makishi lya Zambia: Mask Characters of the Upper Zambezi Peoples* (1998) with detailed analysis provided in English and German. The present volume, *Makishi: Mask Characters of Zambia,* grows from the Jordán-Felix collaboration with a newly elaborated, innovative focus on stylistic typology and an examination of the ways that the meanings and identities of masks may be transformed in relationship to their audiences and contexts of use.

Manuel Jordán has been deeply influenced by the cultural anthropology of the late Victor Turner, who worked in northwestern Zambia (then Northern Rhodesia) in the late 1940s, and by Turner's protégé, Allen F. Roberts, who in turn served as a graduate mentor to Jordán at the University of Iowa. Inspired by these teachers, Manuel Jordán has conducted exceptionally engaged field research, emphasizing social process and changing sociopolitical circumstances. It is Manuel Jordán's deep ties and strong personal relationships with the people of the communities in which he has lived and worked, however, that have enabled him to participate in the boys' *mukanda* initiation rites and to foster the productive relationships with local chiefs and other significant cultural representatives, practitioners, and spokespersons that have led to the explanations and understandings he provides in the present book.

African art history is headed in new directions these days with contemporary and diasporic arts often the most popular areas of focus for young scholars. Research of the kind presented in *Makishi: Mask Characters of Zambia,* which focuses on Africa's continuing traditional art forms and practices, has thus become more necessary and more valuable than ever. The masquerade traditions of Zambian peoples demonstrate that African cultural heritages are in constant states of reformulation. Though they have long histories of use, the masks illustrated here are constantly being updated to reflect changing social circumstances, foreign encounters, and the dynamics of social interaction in a rapidly changing world. In many ways the masks are an alternative social reality—a performative mechanism to explain, cope with, and, often enough, celebrate life's most difficult transitions and transformations. We wish to thank Manuel Jordán for his commitment to this project and for his passionate interest in the subject matter. It has been a great pleasure to work with him on this book and exhibition, as it has been in our previous collaborative projects.

Dr. Jordán joins me in thanking the entire staff of the Fowler Museum for its contributions to this project. As always Museum personnel—listed in full at the back of this book—have fulfilled their responsibilities to the highest standards and are to be commended for their dedication to the work we do. Special recognition goes to the members of our publications team who have produced this handsome volume: Lynne Kostman, Managing Editor; Don Cole, Photographer; and Danny Brauer, Designer and Director of Publications.

We hope that in addition to its obvious contribution to scholarship of the "Three Corners" region, *Makishi: Mask Characters of Zambia* will inspire those who are unfamiliar with Africa, as it reinforces Africa's rich artistic legacy and furthers an understanding of a universal aesthetic phenomenon—the art of masquerade. Masks never cease to produce awe and mystery in their audiences. Those from the Zambian groups represented in this book affirm the capacity of art to empower and transform, while dazzling viewers with their sculptural beauty and dramatic impact.

Mary (Polly) Nooter Roberts
Deputy Director and Chief Curator

Preface
The Way of Masks in Northwestern Zambia

Northwestern Zambia and adjacent lands in southwestern Congo and easternmost Angola constitute a region of great cultural complexity, as Manuel Jordán notes in the pages that follow. A half-dozen more-or-less closely related ethnic groups (Chokwe, Lunda, Luvale, Lwena, Luchazi, Mbunda) interdigitate there, and long-standing relations amongst them and neighbors farther afield are further complicated by more recent refugee flows caused by acute and ongoing civil unrest in both Angola and the Congo. The masquerades that Manuel Jordán has studied and about which he writes so evocatively in these pages reflect histories of compromise and creative tension, but they also dramatize contemporary struggles for survival in oft horrific circumstances of violence and deprivation. In the summer of 1992 when I was fortunate enough to visit Manuel at his Zambian research site in Chitofu hamlet, for example, I saw a performance that included an aggressive *likishi* mask with a flat crest painted with the warning word "UNITA," in reference to the rebel group of Jonas Savimbi that was then causing such dire havoc in eastern Angola. It was clear that this weapon-wielding character was not to be taken lightly.

Jordán informs us that more than one hundred *makishi* are created by peoples of northwestern Zambia and that they perform an intricate theater that may involve small troupes but sometimes quite large groups of masked actors. His breakdown of these character types into four paradigms is very useful and appropriate, extending beyond prior schemas proposed by regional scholars to provide a sense of both visual—that is, formal, following the properties of the masks and costuming themselves—and performance genres. Even more significantly, such a breakdown permits us to grasp how new characters can be created within earlier categories, so that basic dramatic plots are preserved while reference is made to new technologies, aberrant behavior in the community, and other newsworthy events and phenomena. Such a formula for keeping what has been successfully satisfying while providing theater with an adaptive leading edge is, of course, reminiscent of soap operas the world over. In *makishi* performances, though, audience members are not only given an opportunity to reflect upon their personal and collective lives, they are pulled into the drama to dance the foil for the maskers themselves, especially regarding issues of gender, child rearing, and how the community should understand social change.

What I should like to suggest briefly here is that the opposite consideration may also be of complementary interest, for Jordán's paradigms clearly constitute a greater whole. By considering the hundred-plus *makishi* performed in northwestern Zambia, one may perceive semantic fields linking material and performance arts to other expressive domains. I hasten to add that Jordán has taken this very approach in previous writing, such as in his synoptic work with Marc Leo Felix, *Makishi lya Zambia: Mask Characters of the Upper Zambezi Peoples* (1998). But over and above documenting and explaining such a totality, recognition of *systems* of thought and practice may permit reflection upon ways that the congeries of peoples in northwestern Zambia and surrounding territories that Manuel has studied for nearly twenty years now may be compared to cultural complexes elsewhere in central Africa. In turn, this allows an escape from spurious reification of particular culture areas to the detriment of broader understanding of how both confirming and innovative ideas, as well as a more basic logic of expression, are shared among Bantu-speaking peoples throughout a vast region.[1]

The title of this preface is adapted from *The Way of the Masks* (1982) by Claude Lévi-Strauss, in which the great French anthropologist considers masquerades of First Nation peoples of Canada's Northwest Coast. While he is most interested in several mask types that he suggests

may be very ancient and perhaps even related to cultural forms coming from west of the Bering Straits many thousands of years ago (1982, 27), Lévi-Strauss is also taken by "this unceasing renewal, this inventive assuredness…, this scorn for the beaten track," and indeed, "this dithyrambic gift for synthesis… [that] give to the [First Nation] art of British Columbia its unmistakable stamp and genius" (Lévi-Strauss 1982, 4, 8). In underscoring these traits—even those he deems "dithyrambic" (that is, "impassioned" [Morris 1969, 384])—Lévi-Strauss might have been writing of the peoples of northwestern Zambia whose arts similarly demonstrate deep strata of shared creativity as well as up-to-the-minute adaptive potential to meet the needs of new technologies and radical social change.

Lévi-Strauss subjects Northwest Coast masks to structural analysis, asserting that "as is the case with myths" that he has studied so famously, "masks, too, cannot be interpreted in and by themselves as separate objects" dissociated from their cultural matrix (1982, 12). Rather, a transformative semantic field—that is, through which a logical "language" of signs can be discerned—must be considered in which the formal properties of masks, the narratives accompanying them, and the purposes they serve can be understood as "mutually complementary. It is on the level of this total range of meanings" that Lévi-Strauss would place his emphasis (1982, 13–14, 57), and with startling results that reveal the far-reaching intellectual elegance of the Northwest Coast peoples in question. Similarly, the way of masks in northwestern Zambia can be approached as a structural whole that, not despite but *because* of the cultural complexity of the region, can reveal expressive relations amongst ostensibly different ethnic groups and across vast areas that might otherwise be overlooked by more focused ethnography and art history (see Vansina 1984, 176).

The archetypically French style of Lévi-Strauss's structural analysis has not been the theoretical perspective of choice for many expatriate scholars of central Africa, as most have been trained in the empiricist social sciences of Great Britain or the cultural determinism of Anthropology in the United States. A felicitous exception is the extensive consideration of central African origin myths by the Belgian anthropologist Luc de Heusch (1972/1982), who has studied narratives from northwestern Zambia among many others. In particular, de Heusch finds that Lweji, who figures prominently in the royal histories of Lunda-related peoples of northwestern Zambia (and who is portrayed by the "sociable" *likishi* presented in the present book on p. 61), is the symbolic opposite of the antihero Nkongolo-Mwamba found among Luba-related peoples of southeastern Congo and northeastern Zambia (Heusch 1972, 210). The intricate details of de Heusch's presentation need not concern us here, for what is important to the present argument is that through his analysis of myth, de Heusch posits a logical relationship between bodies of knowledge and modes of expression among Bantu-speaking peoples across significant cultural and geographical distances. On such a basis, one can hypothesize that *makishi* masquerades in northwestern Zambia may find their structural equivalents (or dialectical opposites) elsewhere in central Africa, and perhaps even in different forms of cultural expression among people for whom masking is not as significant as it is in northwestern Zambia, or, indeed, among whom masquerade may not be practiced at all.

Of interest here are systems of thought and practice among groups living in southeastern Congo and northeastern Zambia, where ethnicity is imbricated in ways as complex as anything one finds in northwestern Zambia (see A. Roberts 1986, 5–8; and Roberts and Roberts 1996,

211–43). Among Luba and related peoples of this region, material and performance arts are richly elaborated, and among important goals of such expression is to assist in the making of political histories from collective memory. Dramatic forms differ among the peoples of the region, as they do from the masquerades of northwestern Zambia described in these pages; but the hypothesis I would set forth here is that underlying such differences are parallel logical structures from which particular meanings are generated. In other words, I would extend what we know of Luba mnemonic arts to include the possibility that other expressive forms bear similar burdens among the peoples of northwestern Zambia, just as I would work the equation in the opposite direction and say that the theater of *makishi* informs cultural production among Luba and their neighbors.

As Lévi-Strauss asserts, material objects cannot be separated from their narration. Luba living in a "heartland" around the Lualaba lakes still used *lukasa* memory boards during Mary Nooter Roberts's research in the late 1980s, for example (Roberts and Roberts 1996, 116–49). These small wooden boards, studded with beads or incised with ideograms associated with information meant to be remembered, are "read" by those with sufficient esoteric knowledge to do so, especially in contexts when histories important to legal issues are being narrated. The same configurations on a *lukasa* may be used to map and recall different sorts of information, such as incidents from origin myths, protocol seating in a chief's court, or the layout of a chief's medicinal/spiritual garden. Mnemonic details of other art forms such as sculptural stools and staffs can also be narrated, and indeed, such data can be given quite different forms, as when the notes of *lukasa*-shaped musical instruments called "thumb pianos" (the "plucked idiophones" of musicologists) are composed as tone poems. In another application of the same principle, tiny sculptures and symbolically significant found objects held in gourds are used in divination by some Luba and related peoples, as they are by the various ethnic groups of northwestern Zambia. Such gourds are shaken and when the resulting juxtaposition of their contents is interpreted, "life is tossed in a basket" as diviners help their clients to understand the arcane sources and meanings of misfortune, as Manuel Jordán (1996) has described so compellingly. Luba and related peoples have made and used masks as well, but few early examples are known, and very little information exists concerning their purposes and uses. One can assume that they, like their counterparts in northwestern Zambia, were used to dramatize the sorts of stories remembered and told through the memory boards, stools, staffs, and other artistic media mentioned here.

The hypothesis offered in this preface, then, is that ways of organizing thought and taking action through logic, semantic fields, and systematization of information through expressive devices—be they multi-masked dramas, narrations of *lukasa* memory boards, or the tossing of life in a basket—are shared by peoples throughout central Africa, from northwestern Zambia to southeastern Congo. People even more distant undoubtedly participate in these same ways of organizing experience. For example, Lega of east-central Congo, whose displays of mnemonic sculptures associated with the ranks, purposes, and aphorisms of the Bwami Society are well known (see Cameron 2001), surely respond to just such purposes as those described here.

Some examples of material culture make such an assertion obvious, and probably none more so than a comparison of the vignettes of Chokwe chairs with the symbolism of Luba stools that, although in quite different styles and for somewhat different purposes, both cry out for narration. But how about the masks of northwestern Zambia described by Manuel Jordán in these pages: to what might they respond in the material culture of Luba-related peoples?

An aggressive mask created by Chokwe, Luvale, Luchazi, Lunda, and Mbunda peoples that is associated with fertility and success in hunting, is called Chikunza (p. 77) in the present volume), and sometimes this mask is represented among the tiny sculptures used in basket divination. What might be the relationship between these two contexts, over and above the shared symbolism of Chikunza itself? Might the drama of masquerade be conceptually related to the emerging meanings of basket divination? In other words, might the latter be a related form of theater? In a similar manner, might the objects in a Luba diviner's gourd represent shards of meaning detached from the wooden support of a *lukasa* memory board, to be rearranged as a client's issues are interpreted and resolved? My sense is that there *are* commonalities in both of these expressive modes in northwestern Zambia and southeastern Congo, and that deep, logical structures inform them all. My call, then, is for researchers to recognize the parts and paradigms of an artistic whole as Manuel Jordán does in the pages that follow, but to reverse such a course as well, in order to learn of and from the totalities of expression that unite intellectual pursuits among Bantu-speaking peoples across the historical vicissitudes of ethnicity.

Allen F. Roberts

1. The term "Bantu" (lit., "the people") refers here to an enormous family of closely related languages and dialects, as well as the semantic logic that underlies them, as spoken by historically differentiated ethnic groups from southern Cameroon eastward to southern Somalia and extending to the far southern tip of the African continent. This linguistic usage bears none of the negative connotations ascribed to the term "Bantu" in apartheid South Africa.

Acknowledgments

This volume is dedicated to Chitofu Sampoko (1920–2004)—Zambian Lunda diviner, village headman, son of Angolan chiefs, grandfather (*nkaka*), and my African father (*tata*)—who first introduced me to the world of *makishi* masquerades in Zambia at a *mukanda* initiation held for his grandchildren in 1991. His legacy of wisdom and his deep knowledge of Lunda culture are preserved by his family and friends to whom I am profoundly indebted. Members of the Chitofu family—Maliya, Joyce, Royda, Benfrey, Cosmas, Freddie, Charles, Nyamanjiata, Nyakapi, Nyaunice, and many others—have graciously extended hospitality to me and to many of my colleagues, including Elisabeth Cameron, Rachel Fretz, Boris Wastiau, Sonia Silva, Allen Roberts, and Don Merten, who have pursued research at or visited Chitofu village in northwestern Zambia.

Other Zambian friends have also proved invaluable, including Henry Kaumba, Geoffrey Kaweza, Bernard Mukuta Samukinji, and Tibet Daka. My warm gratitude must also go to my wife, Melanie, for her kindness and continuous help, especially her assistance with field research in Zambia in 1997 and 2004. To my parents, Carmencita and Luis, I also give thanks for unconditional support.

No one has been more influential in my studies and academic choices than my former professor and friend Allen Roberts. Al passed on the baton from his own professor, the late Victor Turner, whose seminal anthropological work among the Lunda-Ndembu of Zambia continues to inspire me as an art historian. Other colleagues and friends who provided help, advice, or information relevant to this *makishi* project include Tom Seligman, Marc Felix, Polly Roberts, Bárbaro Martínez Ruiz, Manuela Palmeirim, José Bedia, and Ken Karner. My initial field research in Zambia (1991–1993) was generously funded by the University of Iowa's Project for the Advanced Study of Art and Life in Africa. Subsequent research funding was facilitated by the Birmingham Museum of Art (1997), and the Iris & B. Gerald Cantor Center for Visual Arts, Stanford University, Phyllis Wattis Fund (2004, 2006).

Finally, I would like to express my gratitude to the Fowler Museum and especially to its director, Marla Berns, and its deputy director and chief curator, Polly Roberts, for inviting me to write this volume and to curate the accompanying exhibition on the *makishi* traditions of Zambia. My thanks go as well to the entire Fowler staff for their support in all facets of this endeavor. From my perspective, it is remarkable to bring not only one but a sizable selection of inextricably related masks into a museum collection. I offer my sincere congratulations to the donors and to the Fowler for sharing such a vision.

Manuel Jordán

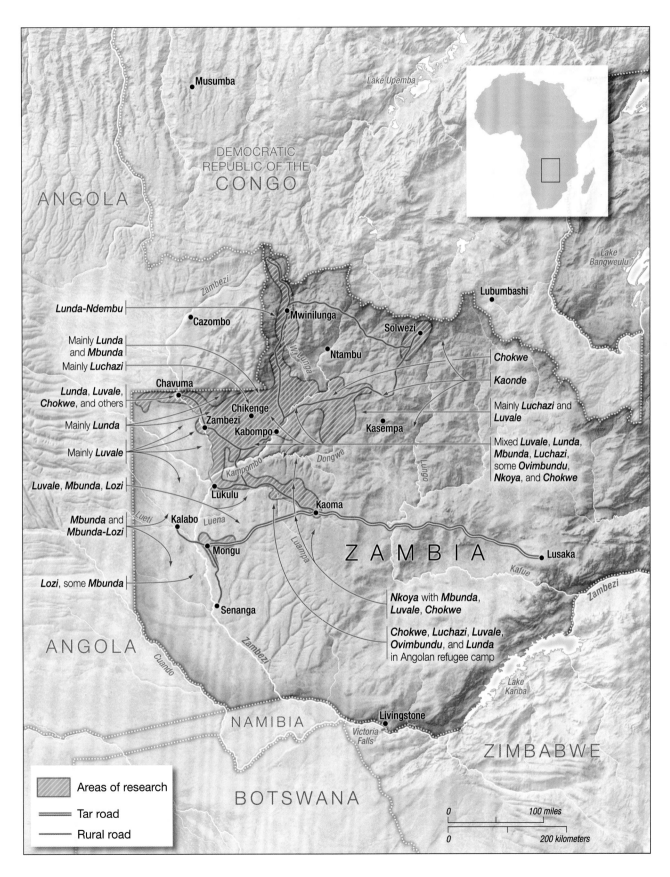

Musumba

Lake Upemba

DEMOCRATIC
REPUBLIC OF THE
CONGO

ANGOLA

Zambezi

Lake
Bangweulu

Lunda-Ndembu

Cazombo

Mwinilunga

Lubumbashi

Solwezi

Mainly *Lunda*
and *Mbunda*

Mainly *Luchazi*

Ntambu

Chokwe

Kaonde

Lunda, *Luvale*,
Chokwe, and others

Chavuma

Chikenge

Mainly *Luchazi* and
Luvale

Mainly *Lunda*

Zambezi

Kabompo

Kasempa

Mixed *Luvale*, *Lunda*,
Mbunda, *Luchazi*,
some *Ovimbundu*,
Nkoya, and *Chokwe*

Mainly *Luvale*

Dongwe

Kampombo

Lungo

Luvale, *Mbunda*, *Lozi*

Lukulu

Kaoma

Mbunda and
Mbunda-Lozi

Lueti

Kalabo

Luena

Luampa

Z A M B I A

Lusaka

Kafue

Mongu

Lozi, some *Mbunda*

Nkoya with *Mbunda*,
Luvale, *Chokwe*

Zambezi

Senanga

ANGOLA

Cuando

Zambezi

Chokwe, *Luchazi*, *Luvale*,
Ovimbundu, and *Lunda*
in Angolan refugee camp

Lake
Kariba

Livingstone

NAMIBIA

*Victoria
Falls*

ZIMBABWE

BOTSWANA

	Areas of research
	Tar road
	Rural road

0 100 miles

0 200 kilometers

13

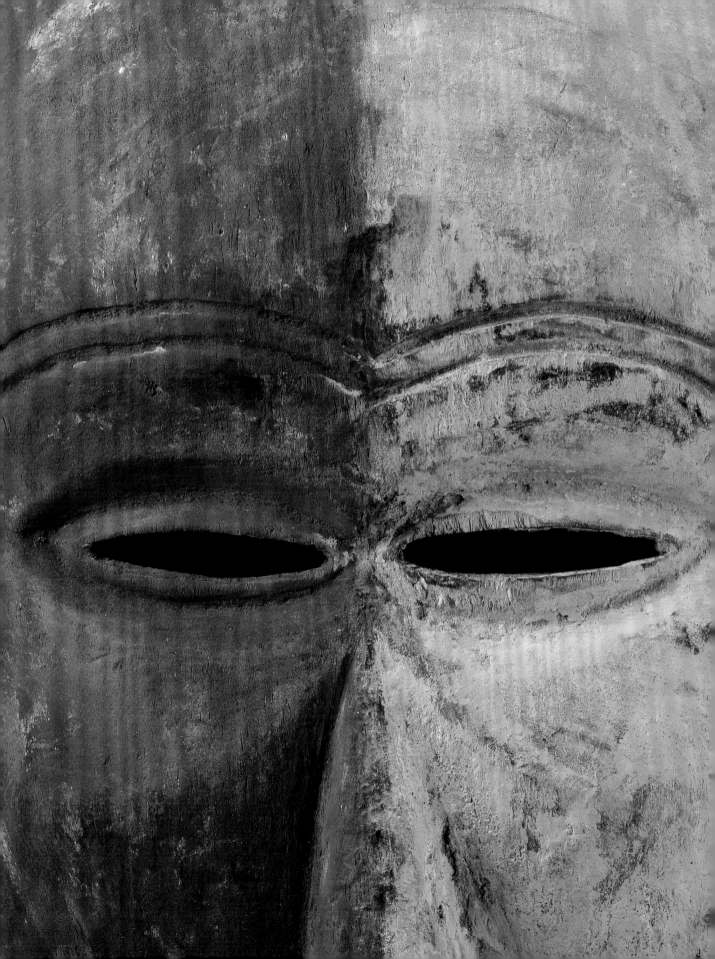

Makishi

Mask Characters of Zambia

[Donning a mask] a man was changed, for though still himself, yet he was not himself.

Picton (1990, 182)

In the West today, rarely is thought given to the social or psychological ramifications of putting on a mask, an activity that is often trivialized and increasingly commercialized. Throughout Africa, however, masking is still often perceived as a transformative process, one that "*causes* a person to assume the nature and being of some other person, spirit, animal, or even abstract quality" (Roberts 1990, 38). The title *I Am Not Myself*, chosen for the seminal volume on African masquerade by art historian Herbert Cole (1985), suggests the paradox inherent in the act of masking and reflects the sense of ambiguity that a person may experience as his identity shifts into or comes to encompass that of something or someone else.

Transformations of this sort often occur in the liminal, or betwixt-and-between, period of rituals when maskers lose themselves or their individual identities and are free to experiment with the definitions and constraints of their social life. There is a shift from an ordinary to an extraordinary state of being. Liminal, or transitional, states induce reflection on "objects, persons, relationships, and features of their environment that [participants] have hitherto taken for granted" (Turner 1982, 105).[1] The efficacy of masks in transformation is not, however, "limited to individual actors' states and their assumption of spiritual form." Rather, "all of society may be experiencing radical transformation" with masks serving as "adaptive mechanisms of critical importance to coping with change" (Roberts 1990, 38).

By virtue of the spiritual or supernatural powers they embody or engage, masquerades— events involving many masked performers—appear throughout Africa to assist in human transitions that range from coming-of-age rituals to funerals. They may appear in order to promote bountiful agricultural seasons; to oversee the investiture of royalty; or, when serving in regulatory associations, to punish delinquents (Sieber 1962). Masks also mediate human conflicts through divination or problem solving and may be summoned during ominous times to help society understand and cope with major calamities such as war and illness. Masquerades are vital art forms at the cutting edge of society, and as such they are in a constant state of adaptation, responding to the new by assimilating and negotiating it in public arenas where redefined or new mask forms are able to address current political issues, new technologies, or any other form of socially critical, current information (Strother 1998; Jordán 1993).[2]

At a more intimate level, masks are heavily nuanced and complex. They have one aspect that is private and veiled in the secret prerogatives of the—usually male—initiation (or other) institutions that create and maintain them, and they have another aspect that is meant to display, advertise, validate, and justify those exclusive premises in a broader social arena by engaging women and the uninitiated, mainly through public performances.[3] In this function, masks, like other African art forms envisioned in secrecy, selectively help disseminate knowledge. They are "fundamental to processes of teaching and revelation that confer status and disclose information" and meanings, while representing one "aesthetic means of ordering knowledge, regulating power, and demarcating differences between genders [and] classes," as well as allowing for other such distinctions (Nooter 1993, 23–24). The crucial role of masquerades in articulating

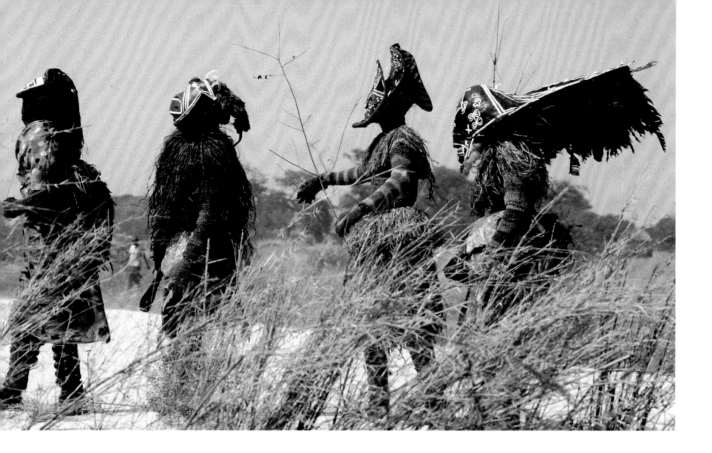

1.1 These *makishi* mask characters are part of a procession that performed at the Likumbi Iya Mize confirmatory ceremony of paramount Luvale chief Ndungu.

PHOTOGRAPH BY MANUEL JORDÁN, NORTHWESTERN ZAMBIA, 1997.

knowledge and aspects of collective experience—including history, morals, and religious and cosmological principles—while at the same time reflecting the ambiguities of life and the advent of change, is perhaps what makes these art forms indispensable. As Cole has observed, "masquerades are probably Africa's most resilient art form" (1985, 16).

To gain a better perspective on the longevity of African masquerades, it should be noted that the oldest-known wooden sculpture from central Africa is a zoomorphic carving, excavated in central Angola and carbon-14 dated to the ninth century (Bastin 1998, 14).[4] This sculpture very closely resembles zoomorphic masks still being made and performed in central Angola. The carving lacks holes in the eyes, which would permit a wearer to see while performing, and the typical holes found around a mask's edge to secure the fiber "neck" part of a costume are also not evident. These "missing holes" have led to some debate over the original function of this sculpture (Bastin 1998, 14).[5] Whether or not the zoomorphic sculpture was actually part of a ninth-century masquerade, it illustrates an early, fully developed sculptural type (a zoomorphic head) with formal qualities and stylistic traits that are still evident in documented zoomorphic mask characters of Angolan and neighboring peoples (Felix and Jordán 1998, 265–71).

In this essay I will consider a rather distinctive group of Zambian masks in the collection of the Fowler Museum at UCLA, focusing on the masquerade traditions of one cluster of related central African peoples who happen to reside around the area where the ninth-century mask was excavated in Angola, extending into Zambia and the Democratic Republic of the Congo. The aim of this study is to provide further insight into the form, function, and context of specific masks in this corpus and—based on recent field documentation—to develop an alternative form of categorization highlighting a variety of individual mask characters by their defined physical attributes and those that become evident in performance.

Makishi Mask Characters

The mask characters of Chokwe, Lunda, Luvale/Lwena, Luchazi, and Mbunda peoples are known as *makishi* (sing., *likishi*) in Zambia and *akishi* (sing., *mukishi*) in their territories in Angola and the Democratic Republic of the Congo (fig. 1.1).[6] In each case the name derives from the

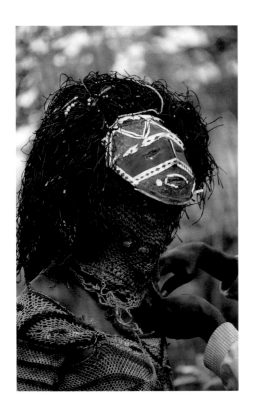

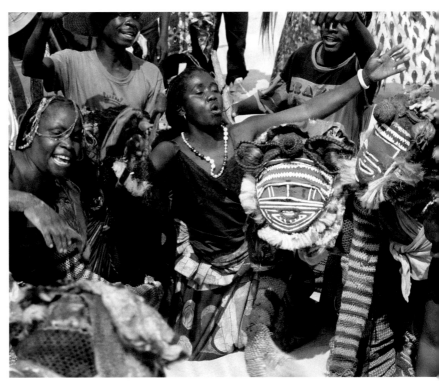

1.2 Dressed in a female *likishi* "head" and "body," this performer at a Lunda initiation camp embodies the spirit of an ancestor and assumes her character and behavioral attributes.

PHOTOGRAPH BY MANUEL JORDÁN, NORTHWESTERN ZAMBIA, 1991.

1.3 Involved in a performance that includes several audience members, the Luvale *makishi* performers at the far right lose their identities as individuals and become engaged in the essence of a male spirit named Chisaluke.

PHOTOGRAPH BY MANUEL JORDÁN, NORTHWESTERN ZAMBIA, 1997.

term *kishi* or *kisi*, a widespread Bantu concept, which denotes the manifestation or representation of a spirit, usually that of a deceased person (*áfu*) or ancestor (*hamba*).[7] Quoting his Lunda-Ndembu informant, Muchona, anthropologist Victor Turner documented that the spirits embodied in *makishi* are those of "famous men such as chiefs, hunters, rich men, men with many children or who have important ancestors." Turner also confirmed that a *likishi* dancer is "helped" by the spirit he embodies (1982, 241). Ethnographer C. M. N. White, who worked among Zambian Luvale, also noted that "*makishi* are traditionally believed to be spirits which have risen from the grave" and that "the notions associated with the masks are highly complex" (1969, 16). He observed as well that *makishi* are "associated with the actual ancestral spirits...of the holder of the rites," some bearing "the name of an important lineage founder."[8] *Makishi* are thus ancestral in nature; they embody the spirits of important and memorable deceased individuals (male and female), and as such they are treated with due reverence.[9]

A *makishi* carver or performer does not normally refer to a *likishi* as a mask or to its costume as an object. Instead, he speaks of the "head" or "body" of the *likishi* (fig. 1.2). This distinction supports the point of view that *makishi* components are potentially active parts of an ancestral manifestation.[10] *Makishi* dancers with whom I worked in Zambia explained that they did not reach a state of being possessed by a spirit while performing. Although they mentioned that spirit possession is indeed possible, they described their experience as "losing" or "forgetting" themselves within the *likishi* character (fig. 1.3).[11] A performer's moves, dance steps, gestures, and behaviors may actually be attributed to a spirit's influence, and he, as an individual, is normally not liable for any troublesome actions that may occur during a performance.[12]

The identity of a performer is supposed to remain hidden from the public, and it is treated as one of the secrets of the *mukanda* boys' initiation camp, the main context for masquerades (see below).[13] *Makishi* belong to the realm of men and are created and performed solely by them. Women, uninitiated boys or men, and outsiders may interact with *makishi* during public ceremonies (fig. 1.4), but individuals are not allowed to reveal or publicly discuss the identity of a *likishi* performer. Doing so may result in severe punishment, the imposition of steep fines, or both.[14]

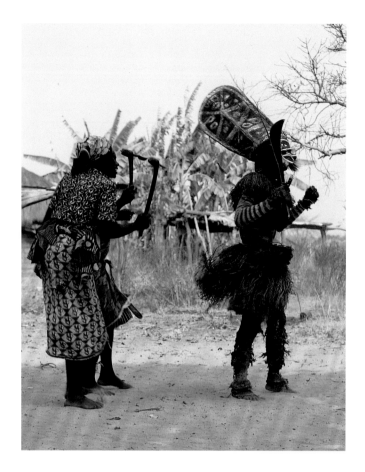

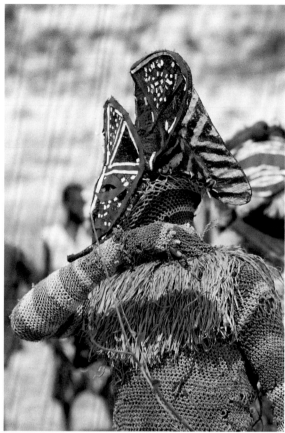

1.4 Two Chokwe women interact with a *likishi* known as Utenu during a *mukanda* initiation performance.
PHOTOGRAPH BY MANUEL JORDÁN, NORTHWESTERN ZAMBIA, 1992.

1.5 Called Kazwazwa, this rather ambiguous Luvale *likishi* was interpreted by different ceremony participants as a "butterfly," an "airplane" (*ndeke*), and a "jet."
PHOTOGRAPH BY MANUEL JORDÁN, NORTHWESTERN ZAMBIA, 1997.

1.6 In this performance in a Lunda village, a Luvale-made *likishi* representing a mature woman dances with Maria Chitofu (left), who imitates the act of fishing, a woman's chore. This interaction highlights the role of women as providers for their families and the community as a whole.
PHOTOGRAPH BY MANUEL JORDÁN, NORTHWESTERN ZAMBIA, 1997.

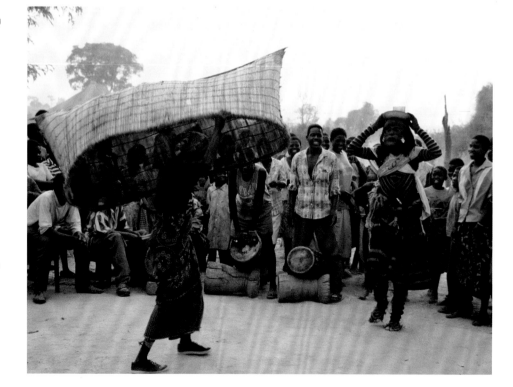

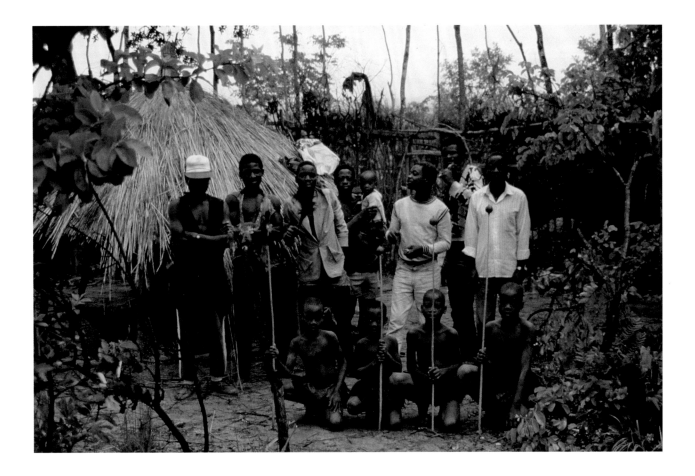

1.7 Four Mbunda *mukanda* initiates pose for a photograph in front of the initiation camp leader (a Chokwe ritual expert) and a group of attendants.

PHOTOGRAPH BY MANUEL JORDÁN, NORTHWESTERN ZAMBIA, 1992.

Makishi masquerades are created and reconfigured constantly, and new forms or characters are devised to comment on current events and situations. Masks that take the form of birds, for example, seem to have expanded to include other "things that fly," with airplane and helicopter masks representing new technologies, foreign things that "may infect you," or a commentary on war as an ominous social transition (fig. 1.5). These masquerades have been active for decades, and new characters take the form of VCRs and boom boxes to name only a few. Such innovative *makishi* reflect technological advances, notions of wealth, and the interests of young people today. Far from functioning as "itinerant clowns" (Horton 1990, 121) or as forms of "profane entertainment" (Bastin 1982, 81), *makishi* serve as agents of ideology (Layton 1981, 43) and social change (Jordán 1993; 1996). They help dramatize and articulate the cosmological precepts, principles of social and political organization, history, philosophy, religion, and morals of those who use them (fig. 1.6).

Mukanda Initiation: The Primary Context for *Makishi*

The term *mukanda* is used to refer to a complex male initiation process and to the initiation camp where novices are kept under the supervision of instructors (Turner 1982, 151–279). Culturally related groups such as Chokwe, Lunda, Luvale/Lwena, Mbunda, and Luchazi share these initiation practices with few variations. In territories where these peoples coexist, joint or ethnically mixed initiation camps commonly occur. Neighboring groups such as Holo, Yaka, and Pende (Batulukisi 1998; Burgeoise 1984; Strother 1998) also practice *mukanda*, and related, although different, initiation practices may be found throughout central Africa.

Mukanda is a secretive male association, its practices centered in the secluded male initiation camp that is normally built as a fenced-in enclosure away from the village and apart from women and the uninitiated (fig. 1.7). Access to the camp is exclusive. Only *mukanda* participants, including initiates, their guardians, ritual experts, and other adult initiated men are allowed in the camp or

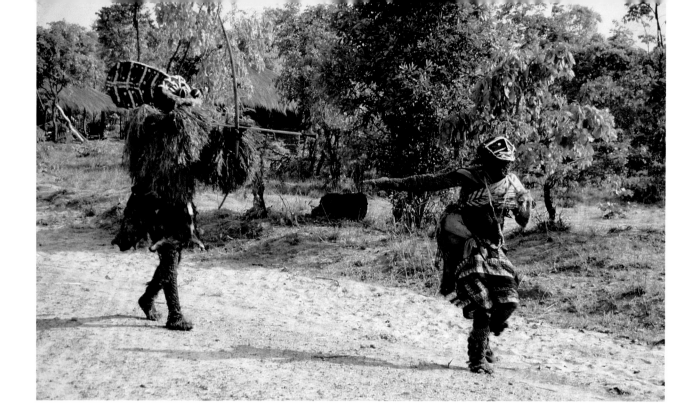

1.8 Two Lunda *makishi* characters perform together, dramatizing their contrasting behaviors. The larger character at the left threatens the other with his bow and arrow.

PHOTOGRAPH BY MANUEL JORDÁN, NORTHWESTERN ZAMBIA, 1992.

its vicinity. The purpose of *mukanda* initiation is to break the childhood bond that boys have with their mothers, effectively introducing them to the world of men and adult male knowledge. During initiation, the symbolic death of the initiates as boys leads to their rebirth as adults upon graduation and their reintroduction into society. *Mukanda* serves as an educational institution where the initiates learn about manhood, sexuality, and the eventual roles they will fulfill as husbands and fathers. They learn as well about matters that range from hunting skills to historical narratives and ethical principles. A significant emphasis is also placed on religion, the spiritual and its manifestations—ancestral masquerades bringing the boys firsthand experience of that realm.

Mukanda encompasses different formalized steps leading toward the boys' eventual graduation. The first step in the coming-of-age journey is the circumcision of novices who generally range in age from seven to eleven. As in other parts of Africa (Griaule 1970, 22–23), circumcision is interpreted as removing the femaleness (foreskin) from the male sexual organ. Field accounts relating the origins of *mukanda* in Zambia (White 1953; Turner 1982, 152–53; Felix and Jordán 1998, 87–88) all trace circumcision to an instance where a boy (in the company of his mother in some versions of the story) accidentally cut himself with a tall grass. When the father (or men) became aware of this, it was decided to fully remove the child's injured foreskin. It was agreed that this "was a good thing" because exposing the glans emphasized masculine qualities and resulted in a clean and proper state of manhood.

Mukanda still remains a very active institution, and boys generally undergo initiation during the months of the dry season (April-October). In Zambia today initiations generally last from two to six months. *Mikanda* (plural form) apparently lasted much longer a few decades ago. Short *mukanda* initiations for boys attending government or missionary schools are now held during school breaks. Male circumcision is very important to the peoples treated in this essay, as an uncircumcised man is not seen as an equal to initiated men in these societies and may be regarded as incomplete or even uncivilized according to local standards of manhood.

Although, as mentioned above, there is a general age range during which boys undergo their *mukanda* initiation, induction into *mukanda* is based on a perceived level of maturity. Men preselect those who will be initiated, and families must prepare for the occasion. Both men and women have prescribed roles and responsibilities that include playing host to large crowds of people during important *mukanda* transitions such as the graduation ceremonies.

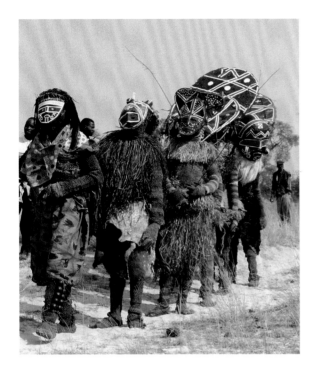

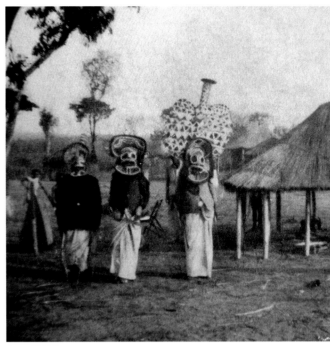

1.9 A line of Luvale *makishi* walk in order according to rank with sociable *makishi* at the front, ambiguous characters in the middle, and aggressive or powerful types at the back.
PHOTOGRAPH BY MANUEL JORDÁN, NORTHWESTERN ZAMBIA, 1997.

1.10 The powerful and sacred Chokwe character Chikungu (right) stands alongside two chiefly *makishi*.
PHOTOGRAPH BY EDUARDO DOS SANTOS, ANGOLA, 1962.

Makishi have a central and essential role in *mukanda*. The ancestral masquerades transit quite frequently from the initiation camp to the village. There they pursue public performances to reassert the camp's prerogatives while engaging women and the uninitiated in celebration of *mukanda* events that mark progress and achievements within the camp. In such a context *makishi* mirror the spiritual backbone of *mukanda* and dramatize aspects of the shared cosmologies and moral, social, and cultural values of the involved peoples. In the privacy of the camp, *makishi* introduce initiates to specialized knowledge, particularly relating to the spiritual. The mask characters also supernaturally protect the novices and the camp from evil (*wanga*) or the ill intentions of evildoers.

Categorizing *Makishi* Characters

Although the *mukanda* initiation of boys into adulthood is the prime context for *makishi*, the masquerades are also performed during the enthronement of chiefs, at their annual confirmatory ceremonies, and at other sociopolitical events.[15] *Makishi* are fashioned to represent more than one hundred characters. These may be human, animal, hybrid, or even abstract in appearance. Different *makishi* have distinct physical, symbolic, and behavioral attributes that relate directly to the particular roles they fulfill in ritual and ceremonial occasions. *Makishi* are not normally performed in isolation or independent of each other. Each character is understood to be part of a larger repertoire of masks.

To better understand the meaning or message conveyed by one mask, its physical appearance and behavior must be compared and contrasted with that of others (fig. 1.8). Defined attributes and dispositions also reflect similarities in character type. In performative contexts such as *mukanda* initiation dances and processions, *makishi* groupings, orders, or hierarchies are observed (fig. 1.9). This is suggestive of broad categories within which *makishi* may complement or substitute for each other.[16]

A few scholars have addressed the subject of classifications for the purpose of understanding and distinguishing *makishi* character types. Art historian Marie-Louise Bastin suggested three major categories for Chokwe masquerades. The first of these is a "sacred" type that consists solely of a character called Chikungu (fig. 1.10), a powerful royal mask kept only by high-ranking chiefs and performed at enthronements, propitiatory ceremonies, or during times of ominous

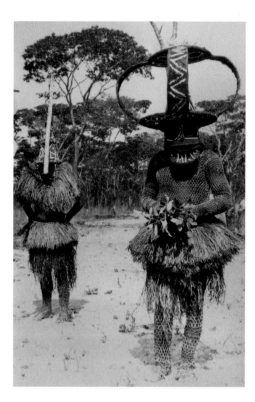

1.11 Postcard showing Kalelwa (right) and Chikuza (left) masks that are probably Chokwe in origin.

ANONYMOUS AND UNDATED.

1.12 Chihongo, who has been described as the Chokwe spirit of wealth and power, sways a fiber skirt in performance.

PHOTOGRAPH BY JOSÉ REDINHA, ANGOLA, 1960S.

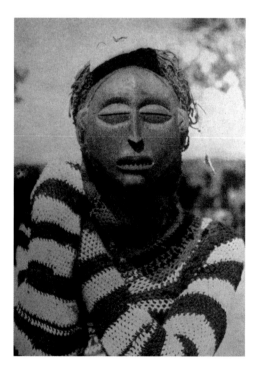

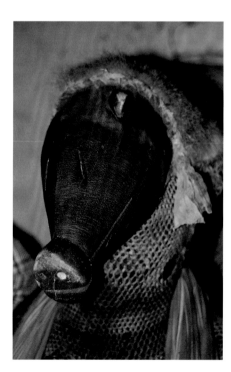

1.13 This *likishi* represents Pwo, the archetypal woman.

PHOTOGRAPH BY JOSÉ REDINHA, ANGOLA, 1960S.

1.14 Ngulu (the pig) is included in Bastin's "dance mask" category.

PHOTOGRAPH BY MANUEL JORDÁN, NORTHWESTERN ZAMBIA, 1992.

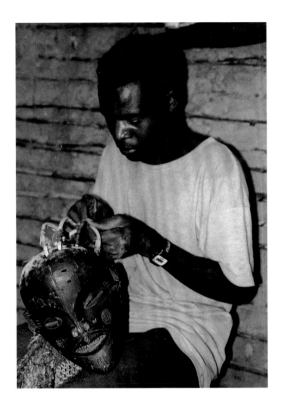

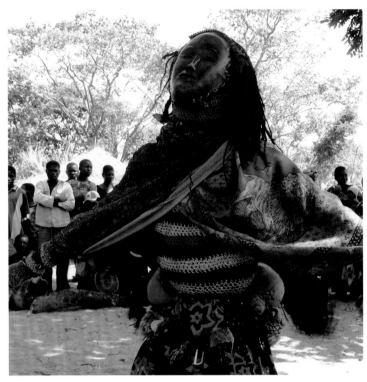

1.15 Charles Chitofu, a Chokwe-Lunda *makishi* maker and dancer, fixes a *likishi* head before a performance.

PHOTOGRAPH BY MANUEL JORDÁN, NORTHWESTERN ZAMBIA, 1991.

1.16 A Pwevo *likishi* representing an elegant woman performs in the context of an Mbunda *mukanda* initiation.

PHOTOGRAPH BY MANUEL JORDÁN, NORTHWESTERN ZAMBIA, 2004.

transition for society as a whole (1982, 81–92). The Luvale have an equivalent mask, called Kayipu or Kahipu, considered the "king" of all *makishi*. Bastin's second category, "circumcision masks" with specific roles in relation to *mukanda*, includes masks such as Chikuza and Kalelwa (fig. 1.11), which are auspicious for the initiation camp and initiates and have symbolic attributes related to fertility, strength, endurance, and continuity. Her third category consists of "dance masks," which she defines as secular and performed as forms of "profane entertainment."[17] This category includes Chihongo, a Chokwe spirit of "wealth and power"; Pwo (called Pwevo in Zambia), the female ancestor; characters such as Katoyo ("the white man, foreigner or outsider"); and various animal characters including Ngulu (the pig) and Hundu (the baboon; figs. 1.12–1.14).

Historian Patrick Wele, himself of Luvale heritage, suggests two categories for Luvale *makishi* characters (1993, 22–26, 58–63). His first category includes Kayipu (equivalent to Bastin's Chikungu in her "sacred" category), as well as Kalelwa, Mupala, and Katotola, which Bastin refers to as "circumcision masks." Wele's second division is similar to Bastin's "dance masks" category, although he implies that subdivisions can be distinguished on the basis of character attributes.

The following typological model for Zambian *makishi* is meant to complement these earlier documented categorizations of mask types. It is based on my own observations of *makishi* performances in chiefs' confirmatory ceremonies and at numerous *mukanda* initiations in Zambia, as well as on accounts provided by various Zambian friends and field assistants, including mask makers, performers, and *mukanda* camp leaders (fig. 1.15). As has been suggested above, *makishi* characters can be distinguished by observing their distinctive physical and behavioral attributes. Combined, their physical appearances and demeanors help subdivide all *makishi* into sociable, ambiguous, aggressive, and royal categories. Sociable *makishi* often dance with participatory audiences to celebrate *mukanda* events. Because of their amicable and celebratory demeanor, they are also known as dancing *makishi*. This category includes anthropomorphic male and female masks, representations of the foreigner or outsider, and zoomorphic *makishi*.

The sociable category may be further subdivided, and within the subcategory of sociable female characters, the representation of Pwevo or Pwo, the archetypal woman, is probably the most recognizable and popular of all *makishi* (fig. 1.16). Until recently, all female *makishi* were

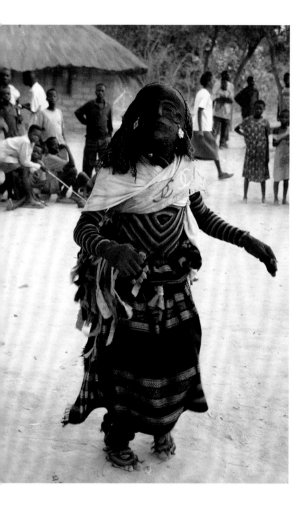

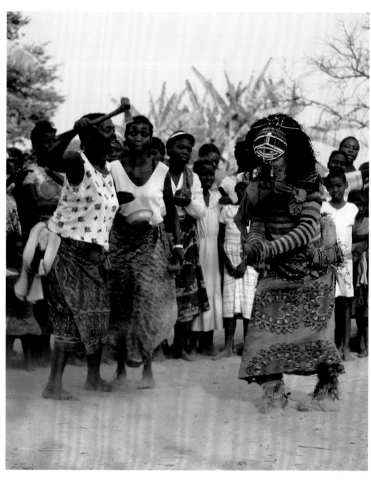

1.17 This Luvale *likishi* represents Kashinakaji, an old woman, and honors mature women in its performances.

PHOTOGRAPH BY MANUEL JORDÁN, NORTHWESTERN ZAMBIA, 1997.

1.18 Two Chokwe women dance alongside a female character known as Chiwigi, testing the skills of the male performer.

PHOTOGRAPH BY MANUEL JORDÁN, NORTHWESTERN ZAMBIA, 1991.

interpreted as the ideal, beautiful woman. Ongoing field documentation has revealed, however, that Chokwe, Lunda, Luvale/Lwena, Luchazi, and Mbunda carvers create several female characters to discern differences in age or maturity, social rank, fashion and modernity, moral values, and self-identity. Illustrated in the catalog section, a group of female *makishi* (cat. nos. 1–12) affords us an opportunity to consider these nuanced interpretations, which include Pwevo (the woman), Mwana Pwevo (the young woman), Chiwigi (the stylish or vane woman), Kashinakaji (the old woman), and others (fig. 1.17). It is pertinent to recall that all *makishi* are created and performed by men. In the case of female characters, women will commonly dance alongside these *makishi* to challenge the performers' skills and make sure that the dances and actions of the masked characters honor them appropriately and sufficiently (fig. 1.18).

The sociable male characters are also diverse, and many of them are perceived as counterparts to female *makishi* although they very rarely dance as pairs. Included in this category are representations of royal ancestors that symbolically support values associated with manhood such as effectiveness in hunting, virility, power, and prowess (see Chihongo, p. 62). Other male *makishi* such as Chileya or Chiheu and Chisaluke lead, direct, and conclude *mukanda* initiation rituals, serving as guardians and instructors of the initiates (fig. 1.19). Additional male characters represent sociable types and play educational roles in their performances. Katoyo or Chindele (who is occasionally performed as female) dances as a parody of the European or foreigner. Similar masks are performed to ridicule neighbors from ethnic groups that do not practice *mukanda* (fig. 1.20). These masquerades are normally tongue-in-cheek, and most of the people in the audience who are parodied do not actually realize that they are the subject of the entertainment. Such masks may include pointed noses or facial hair, which are meant to reflect the "ugly"

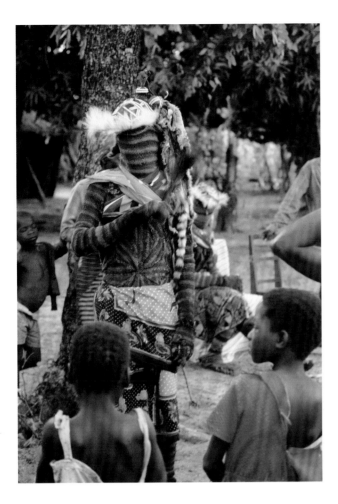

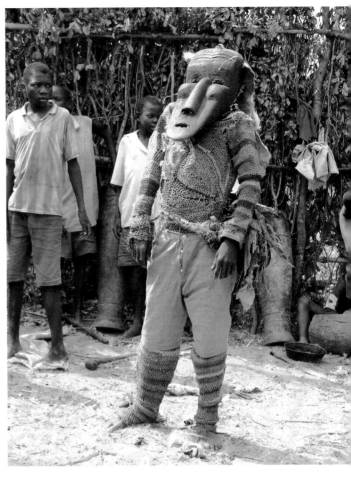

1.19 This Luvale Chisaluke *likishi* (a second Chisaluke is visible seated in the background) represents a guardian and tutelary ancestor of *mukanda* initiates.

PHOTOGRAPH BY MANUEL JORDÁN, NORTHWESTERN ZAMBIA, 1992.

1.20 The awkward facial features of this Mbunda *likishi*, called Simonda, parody the physical appearance of the neighboring Lozi peoples, who do not practice *mukanda*.

PHOTOGRAPH BY MANUEL JORDÁN, WESTERN ZAMBIA, 2006.

features of outsiders. In their performance, Katoyo maskers make inappropriate gestures or may dance with a phallic appendage to illustrate the uncontrollable and uneducated behavior of foreigners or outsiders. Characters such as Ndondo (the fool) are also included in these masquerades to provide an example of that which is socially unacceptable and not to be imitated (fig. 1.21). Ndondo, who is short in stature and has a swollen stomach, may threaten the audience with a knife, beg for money, or touch women in an improper manner.

A second broad category of *makishi* includes ambiguous characters. These *makishi* symbolically embody principles of secrecy guarded by men in relation to their initiation practices (Nooter 1993). Audiences generally keep a distance from these characters because their presence and their enigmatic appearance and behavior imply extraordinary supernatural powers. The character Chikungila stands for a number of masks that are perceived as ambiguous and generally viewed from a reasonable distance. Such characters are believed to possess the ability to see invisible things. They usually appear in a village and stand still for awhile. Then they proceed to look behind doors and around houses, finding hidden things and discovering materials that may be associated with sorcery (fig. 1.22). During this process, they are free to seize items that they like: hats, radios, and utensils. These are taken back to the *mukanda* camp and shared by the men. On occasion, an ambiguous *likishi* may grab a baby from the arms of its mother and take it away. The mother will frantically chase the character, battle it, and seek the assistance of a male relative in retrieving her child, if necessary. This drama helps to process gender tensions that are often symbolic and directly related to the event of *mukanda*, the moment when mothers lose their male children to the world of men.[18]

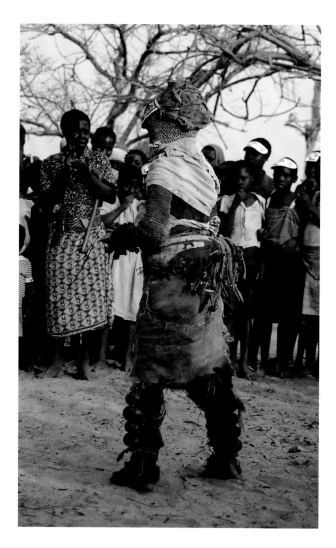

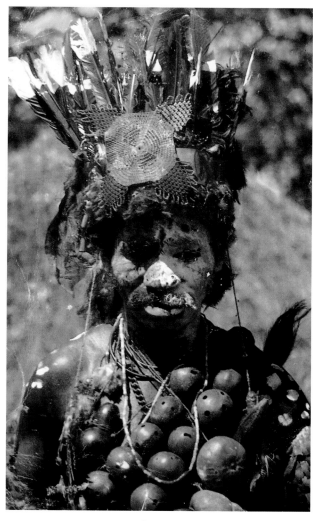

1.21 Ndondo—in this case a Lunda example—is a character typically represented as having a swollen stomach. This mask character performs with bad manners to serve as an example of behavior to be avoided. The performer is usually a short person or a small initiated boy.

PHOTOGRAPH BY MANUEL JORDÁN, NORTHWESTERN ZAMBIA, 1992.

1.22 A Zambian postcard shows a Lunda diviner with his face painted half-red and half-white. Some ambiguous *makishi*, like Chikungila (see cat. no. 22), exhibit similar facial painting; others feature one red and one white eye. This highlights the tension between the positive (white) and ominous (red) sides of things. Like diviners, some ambiguous *makishi* can see invisible things and reveal agents of malevolence.

ANONYMOUS AND UNDATED.

Aggressive *makishi* include some of the largest and most dramatic masks. These characters share the supernatural abilities attributed to ambiguous masks, but their normally contentious behavior and intimidating physical attributes place them above other masks in a socially under-stood hierarchy of power. The main role of aggressive *makishi* is to protect the initiation camp from intruders, physical or supernatural. Aggressive masks brandish weapons and actively chase and threaten the uninitiated, particularly women (fig. 1.23). During key initiation performances, however, they may relax their behavior a bit to dance and celebrate with women, assuming a passive-aggressive demeanor (fig. 1.24).

These aggressive characters often feature anthropomorphic facial features that are exaggerated to display bulging foreheads and cheeks and large mouths. Most of these *makishi* incorporate dramatic headdresses with arches, some with extending "antennae" or horn-like elements. The masks are commonly made from resinous materials, such as beeswax, pitch, or road tar, applied over twig and fiber frames. Whereas the carved wooden masks that are principally used for sociable characters are usually commissioned from professional carvers (fig. 1.25), these larger aggressive-character masks are constructed inside the initiation camp as a collaborative effort on the part of *mukanda* attendants (fig. 1.26). These large *makishi* are normally burnt, along with the *mukanda* camp, after the initiation is concluded. In fact most *makishi* constructed with ephemeral materials are burned at the end of *mukanda*. Camp leaders may keep some of the smaller masks for future initiations, but the larger *makishi* are difficult to

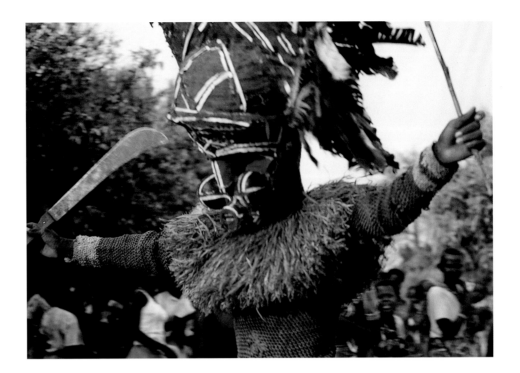

1.23 This Luvale *likishi* represents Mupala, an aggressive character who brandishes his weapon of choice, a machete.

PHOTOGRAPH BY MANUEL JORDÁN, NORTHWESTERN ZAMBIA, 1992.

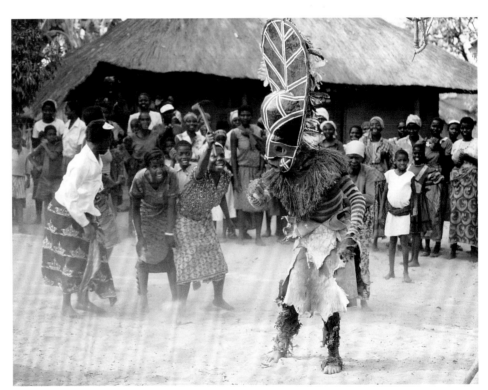

1.24 A Mupala *likishi* in a temporarily relaxed state dances with women in the context of a Chokwe-Luchazi *mukanda* initiation.

PHOTOGRAPH BY MANUEL JORDÁN, NORTHWESTERN ZAMBIA, 1991.

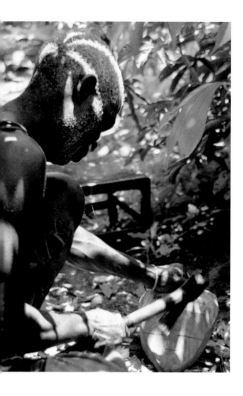

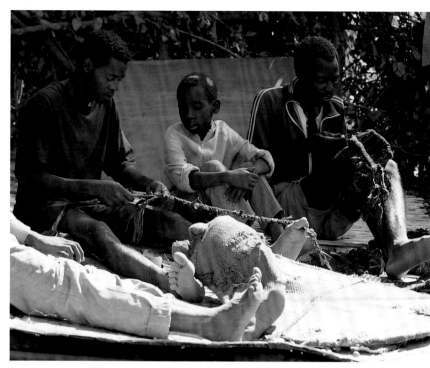

1.25 Mr. Lipeho, an Mbunda carver, works on a commissioned wooden mask representing a female character.
PHOTOGRAPH BY MANUEL JORDÁN, NORTHWESTERN ZAMBIA, 1992.

1.26 Men construct *makishi* inside a Lunda initiation camp enclosure.
PHOTOGRAPH BY MANUEL JORDÁN, NORTHWESTERN ZAMBIA, 1992.

hide between *mukanda* seasons. They are destroyed so that they are not discovered by women or the uninitiated. Burning masks with the camp is intended to return the camp and its contents to the world of the ancestors. The camp is set ablaze at night, and this fire is considered to have extreme supernatural powers. *Mukanda* members do not look back at the fire for fear that it may cause their impotence.

The fourth, and last, mask category consists of royal *makishi*. They include a handful of larger-than-life characters—including Chikungu and Kayipu or Kahipu (fig. 1.27)—which are restricted to chiefs' ritual or ceremonial contexts. These characters do not normally partake in *mukanda*-related events. In the context of Luvale paramount chief Ndungu's annual confirmatory ceremonies (Likumbi lya Mize), Kayipu is joined by a procession of all *makishi*. The royal mask, escorted by the character Pwevo (the woman), leads the procession into the chief's palace compound. There Kayipu sits on the "throne" (a chair or mortar turned upside down), and the rest of the *makishi* sit or kneel on the ground facing him. This symbolically reinforces the royal stature of Kayipu over the other mask characters and mirrors Chief Ndungu's arrival at the court in the company of his wife, as they sit on their thrones on a stage higher than all other guests—including other chiefs from the region, honored visitors, and the general audience. The performance thus becomes one manner of articulating *makishi* categories and hierarchies.

1. Turner's comment is in reference to initiates, but it is made in the context of *mukanda* rituals and liminal states that are equally pertinent to the experiences of mask performers.
2. Examples of new or redefined masquerade forms are provided in the "Makishi Mask Characters" section of this essay (see p. 19, fig. 1.5).
3. Women, no doubt, play complementary roles in support of male initiations and other such institutions. See Cameron (1998a; 1998b).
4. This early sculpture is in the collection of the Musée Royal de l'Afrique Centrale, Tervuren.
5. The zoomorphic sculpture may very well have been used as a type of mask, worn on a performer's head but not covering his face. The mask's angled section could have covered the back of the wearer's neck. Instead of a fiber-woven, net-like costume or dress (typical of most Angolan masquerades documented from the late nineteenth century to the present), the performer of such a mask could have held animal pelts to conceal parts of his body, while looking straight out from

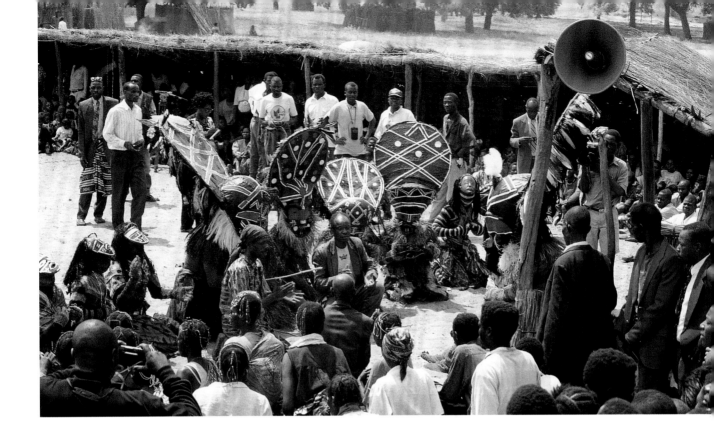

1.27 Kayipu, seated at the right, is the royal mask character of the Luvale. At Chief Ndungu's confirmatory ceremony, Kayipu is honored as paramount by other *makishi* characters.

PHOTOGRAPH BY MANUEL JORDÁN, NORTHWESTERN ZAMBIA, 1997.

below the chin of the mask, something that most mask performers prefer to do today even if a mask includes eye holes in its design. In fact, some adult initiation masks still seen in the field today are held in front of the performer's face with a large animal pelt used to conceal the rest of his body.

6. The information provided in this essay is based on fieldwork conducted in western and northwestern Zambia from 1991 through 1993 and in 1997 and 2004. My principal field research colleagues on the topic of *makishi* include the late Chitofu Sampoko (Lunda), Bernard Mukuta Samukinji (Chokwe), Henry Kaumba (Luvale-Luchazi), Charles Chitofu (Chokwe-Lunda), and Benfrey Chitofu (Lunda). I would like to express my appreciation to these and other field collaborators, while acknowledging that I am solely responsible for the contents of this article and any errors it may contain.

7. See Fisher (1984), Horton (1990), and Barbosa (1989) for Lunda, Luvale, and Chokwe variations on the terms and complementary interpretations.

8. *Makishi* bear "generic" character names, but they may also be addressed by the names of the actual ancestors they embody.

9. When a mask performer dies, his mask may be buried with him or it may be placed in a shrine alongside other ancestral art forms (such as wooden, sculptural figures) to honor the spirit of the dancer. A mask may be inherited by a new performer provided that he is very talented and willing to go through rituals intended to appease the spirit of the deceased performer. An inherited mask may be perceived as having greatly increased powers. Not only is it a threshold for the spirit of the ancestor originally embodied by the mask, it also provides access for the spirit of the deceased performer who may have danced the mask for many years.

10. *Makishi* costumes, or "bodies," are created independent of the masks, and different costume parts may be randomly matched with different masks. Even if these parts are not yet associated with a mask, they are considered to be "potentially charged" elements and are thus not treated casually. If during a performance part of a costume or a mask's coiffure were to become detached from the *likishi*, the performer's assistant would immediately collect it. Evildoers could use such parts as supernatural medicines against the initiation camp, initiates, and attendants, and this must be prevented.

11. Exhaustion from the dance and alcohol intake may enhance this altered state of consciousness.

12. A woman may, for example, be accused by her husband of flirting too much with a *likishi*. The case may make it to a local court, but the identity of the performer will not be revealed.

13. For more information on *mukanda* initiations see Felix and Jordán (1998, 85–125) and Jordán (1998). For a detailed anthropological account of *mukanda* among the Lunda-Ndembu of Zambia see Turner (1982, 151–279).

14. See Jordán (1993) for the role of *makishi* in challenging a chief's position in relation to Zambian elections and how this "hidden identity" may be used as a political strategy.

15. "Culture groups" or "*makishi*" clubs with mask performers exist in different towns and cities in Zambia, including Lusaka, and dancers may be hired to dance at political rallies, at cultural events organized for visitors, and in other contexts. The first *likishi* I ever saw performing danced every Sunday at the Kabompo jail grounds, "to bring support and happiness to the prisoners."

16. When men discuss different *makishi* characters, they inevitably speak of hierarchies and character groupings based on their "power" and defined behaviors.

17. I disagree with the idea of *makishi* being described as a form of "profane entertainment," which seems to suggest that these performances are not as "serious" as they once were. Entertainment was and continues to be a strategy for the transmission of knowledge and relevant sociocultural information, and these masquerades retain important symbolic and religious associations.

18. For a female perspective on *mukanda* initiations and *makishi,* see Cameron (1998a; 1998b).

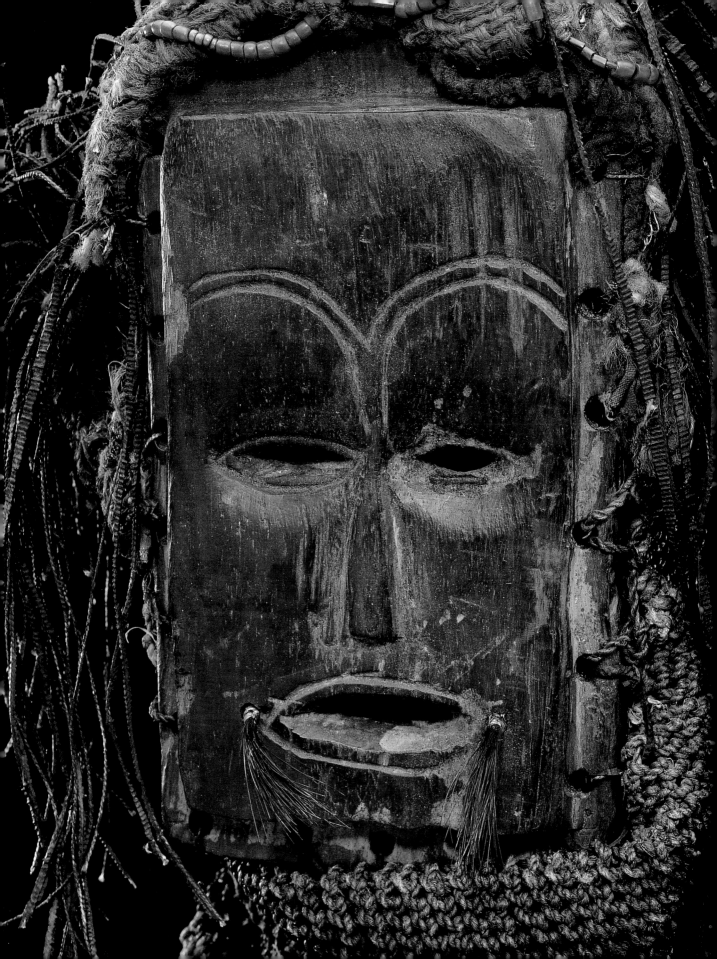

Catalog

In the catalog that follows I will examine specific *makishi*, or mask characters, from the collection of the Fowler Museum at UCLA. Represented are examples of sociable female and male masks, as well as ambiguous and aggressive *makishi*, all of which are used in the *mukanda* initiation process. Missing from the collection are royal-type characters such as Chikungu and Kayipu (see fig. 3.22). Royal characters are exclusive to the courts of a relatively few paramount chiefs. These *makishi* may only appear once a year for the chief's confirmatory ceremonies or on uncommon occasions when they use their extraordinary supernatural prowess to mediate ominous transitions for society on behalf of the ruler. The royal characters are thus rarer than *mukanda* initiation masks, which are created and performed throughout the territories of the peoples under consideration during the dry seasons. Royal masks are considered the most sacred of all *makishi*. Because of their scarcity and religious significance, chiefs would rarely part with them, and very few exist today in museum collections.

Following this catalog, in the last section of the book, behavioral and physical attributes of masked performers are considered according to the typology set forth in the essay. It should not be forgotten that these masks, as stunning as they may appear when encountered in a museum, were once worn in a variety of dynamic performative contexts and that each category of mask had distinctive ways of relating to other types of *makishi* and to various audiences and audience members. Examples of royal masks are illustrated in this final section as well as the sociable, ambiguous, and aggressive masks that make their appearance during *mukanda*.

Sociable Female Characters

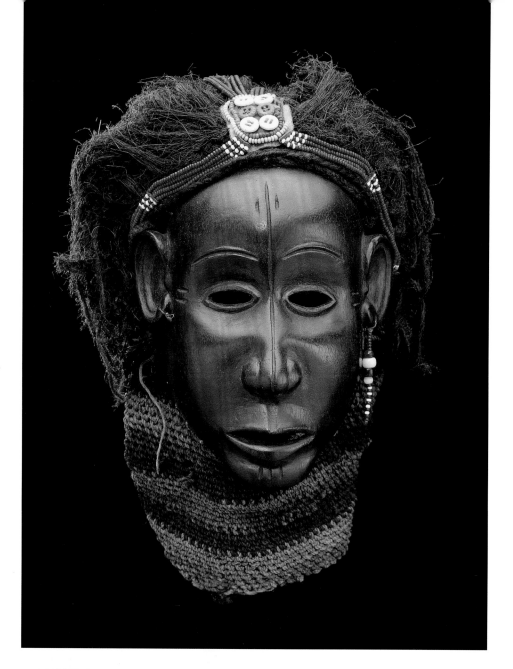

Cat. no. 1

**Pwevo or Kalunda
(woman or Lunda woman)
Lunda peoples, Zambia**

Wood, plant fiber, beads, buttons
H: 35 cm
X2002.33.2

The well-balanced proportions of this mask—its rounded contours and finely defined ears, nose, and lips—lend it a portrait-like quality, and carvers are sometimes inspired by the physical attributes of a particular woman. In this case the mask may honor a female ancestor, or it may represent Kalunda, a female character who stands for the beauty and elegance of all Lunda women (fig. 2.1). In performances, this ideal of beauty is contrasted with the physical characteristics of neighbors and foreigners who are the subject of less-flattering masquerades (as in the case of Katoyo masks; see fig. 1.20 and cat. nos. 19–21). The colorful beadwork and button decoration on this mask is indicative of wealth and maturity. Mothers and other female relatives of *mukanda* initiates wear this type of beadwork as hair decoration during initiation ceremonies.

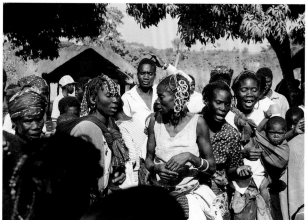

2.1 Four generations of Lunda women perform at a *mukanda* initiation for their boys. The *likishi* Kalunda is created to honor all Lunda women.

PHOTOGRAPH BY MANUEL JORDÁN,
NORTHWESTERN ZAMBIA, 1991.

Cat. no. 2

Pwevo (woman)
Mbunda peoples, Zambia

Wood
H: 23 cm.
X2002.33.6

Helmet-type masks such as this one are extremely rare among the peoples who form the subject of this study. Without the hair or headdress that would once have been attached, it is difficult to identify the character represented, but it is most likely a depiction of an archetypal woman, Pwevo. The open mouth with its sharp triangular teeth is a stylistic trait that Mbunda peoples share only with Chokwe groups in Angola and the Democratic Republic of the Congo. Luvale, Luchazi, and other Zambian peoples typically use small sticks or bones to serve as teeth in their masks. The three lines below each eye represent scarification marks known as *masoji*, or tears. These may be interpreted as "tears of accomplishment," and in the context of initiation they may honor the lament of mothers whose sons will undergo a symbolic death in *mukanda* so that they may be reborn as adults upon graduation.

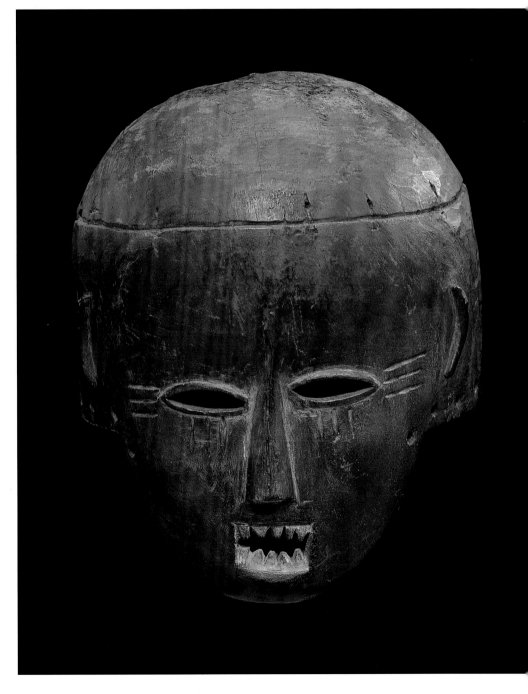

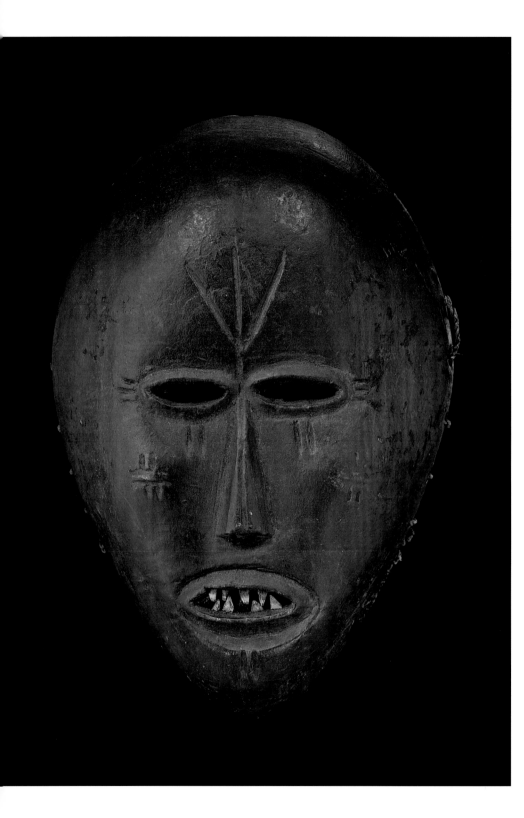

Cat. no. 3

Pwevo (woman)
Ovimbundu, Luchazi, or Luvale
peoples, Zambia

Wood, plant fiber, bone
H: 24.3 cm
X2002.33.1

The scarification mark on the forehead of this mask is commonly found in figures made by Ovimbundu peoples in their Angola homeland. Ovimbundu are the westernmost neighbors of the peoples considered here, and they share with them cultural traits including *mukanda* initiations (Hambly 1934). Although they have migrated into Zambia for decades, Ovimbundu remain a minority there. This mask is carved in a typically Zambian style, however, and it may thus be either an Ovimbundu carver's interpretation of the archetypal woman, Pwevo, or a Luchazi or Luvale mask with a comparable symbol. Through extensive dealings with their neighbors, Ovimbundu have long pursued the trade of goods between the African interior and the Angolan coast. With the exchange of ideas that such trade entails, it is not uncommon to find Zambian, Luvale, Luchazi, or Mbunda carvers incorporating the same scarification mark in their masks. In Zambia and Angola this forehead symbol is described as the footprint of a chicken.

Cat. no. 4 (opposite)

Pwevo (woman)
Luvale peoples, Zambia

Wood, hair, cordage, beads
H: 34 cm
X2002.33.3

The prominent cross-within-a-circle motifs that appear on this mask represent a scarification mark known as *chijingo* (pl., *vijingo*). *Chijingo* symbolically represents the four cardinal points of the compass and the journey of the sun from sunrise (life) to sunset (death) and back. It thus suggests the cyclical and regenerative nature of life. This type of scarification can still be observed on the faces of some adult women in areas of Zambia, although it is rarely acquired today. Up until the mid-twentieth century, however, full body scarification was common as an indication of social status and a reflection of increased knowledge obtained through successive adult initiations.

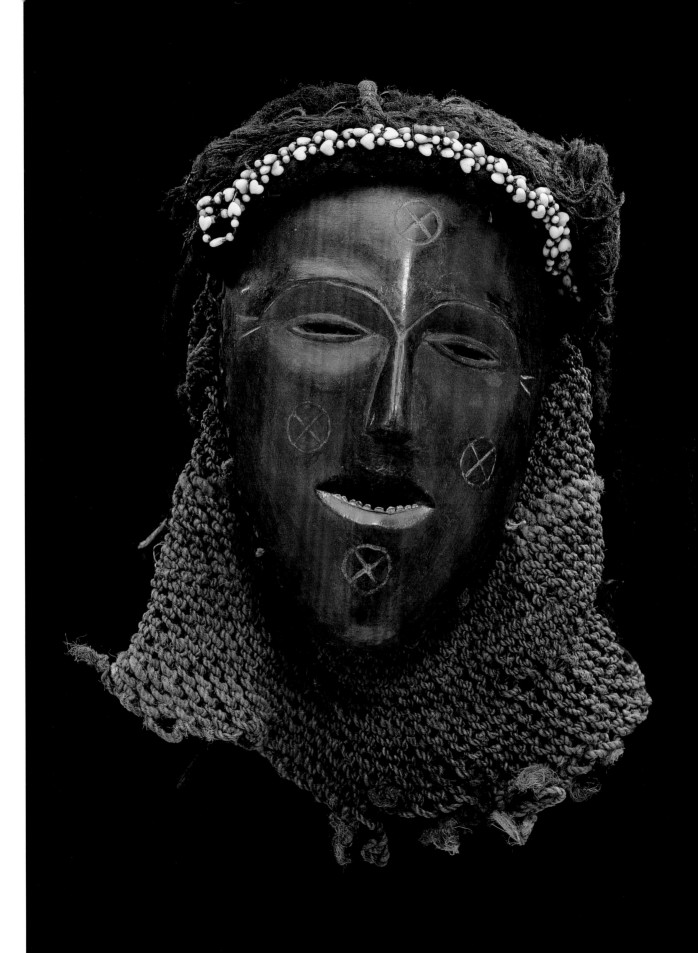

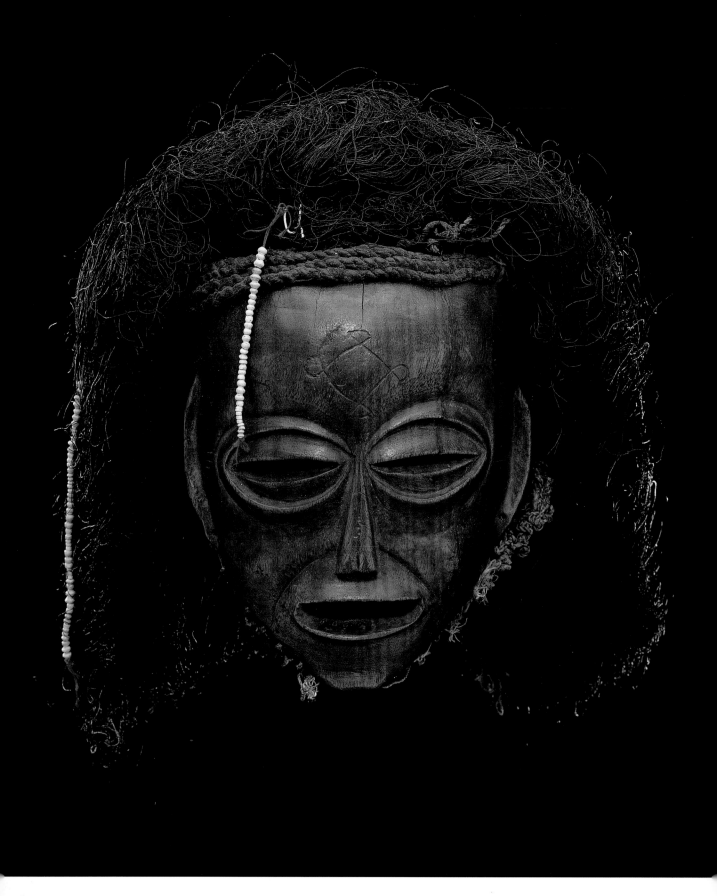

Cat. no. 5 (opposite)

**Mwana Pwevo or Chiwigi
(young woman)
Chokwe peoples, Zambia**

Wood, plant fiber, yarn, beads
H: 29 cm
X2002.33.5

This mask's slightly opened, convex eyelids set within large concave eye sockets are Chokwe in style, and the scarification mark represented on the forehead is the *chingelyengelye*, a symbol of Chokwe identity. The open mouth, to which sticks were once added as teeth, is, however, more of a Luvale or Luchazi mask-making convention. This mask illustrates the typically Zambian merging of carving styles, which is to be expected in a region where related peoples share territories, commonly intermarry, and send their children to joint initiation camps. This character may represent a young woman, Mwana Pwevo. More specifically, the abundant wig-like hair may have been used to identify her as Chiwigi, a stylish or vane young woman, when the mask was last performed (cf. cat. no. 6). The name Chiwigi is derived from the English word "wig."

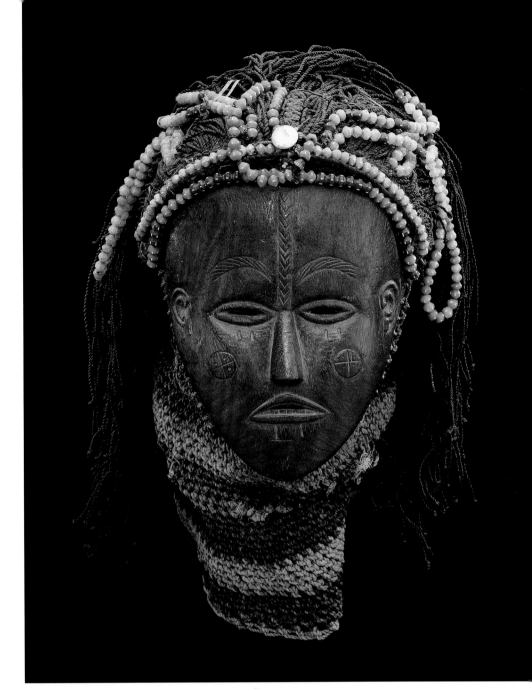

Cat. no. 6

**Pwevo reinterpreted as Mwana Pwevo or Chiwigi (young woman)
Luvale peoples, Zambia**

Wood, plant fiber, cordage, beads
H: 37 cm
X2002.33.4

The elaborate facial scarification marks on this female mask would usually indicate a mature woman. Hairstyles, however, are also important in distinguishing the intended demeanor and age of a specific character. The wig-like hair used on this mask is commonly associated with a woman in her youth. This style of long, straight wig is considered a "modern" commodity, and women who wear it may be perceived as beautiful and stylish (fig. 2.2) or as vane and shallow. A hairstyle may thus alter the interpretation of a mask. In this case it is probable that the mask was originally conceived as a woman, Pwevo, and later reinterpreted as a young woman, Mwana Pwevo or Chiwigi.

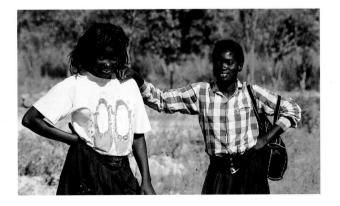

2.2 The young Lunda woman on the left wears a wig of the type used in Chiwigi masks.

PHOTOGRAPH BY MANUEL JORDÁN,
NORTHWESTERN ZAMBIA, 1993.

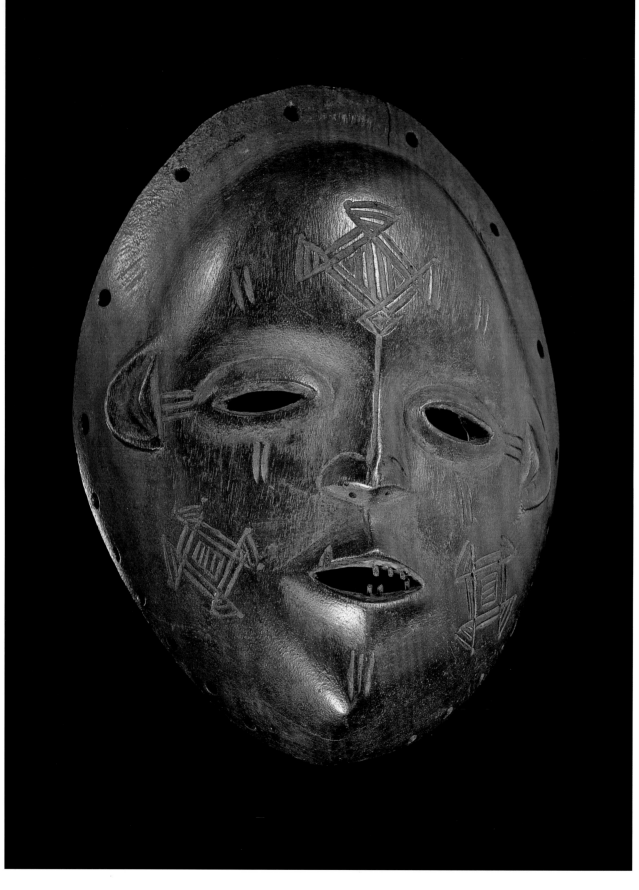

Cat. no. 7 (opposite)

Pwevo or Nalindele (woman)
Luvale peoples, Zambia

Wood
H: 22.6 cm
X2002.33.9

Masks of this shape, with slightly
protruding chins and rather delicate
facial features, are readily identified
by western Zambian Luvale as
Nalindele, which seems to be
a regional name for Pwevo, the
woman. It has been suggested
that this name derives from the
word *chindele*, meaning "white
person." If this is the case, local
ideals of female beauty may have
merged with an appreciation for the
appearance of some foreign women.
This is particularly interesting when
considered in conjunction with
less-flattering views of the outsider
or foreigner as represented by
Katoyo masks (see fig. 1.20 and
cat. nos. 19–21).

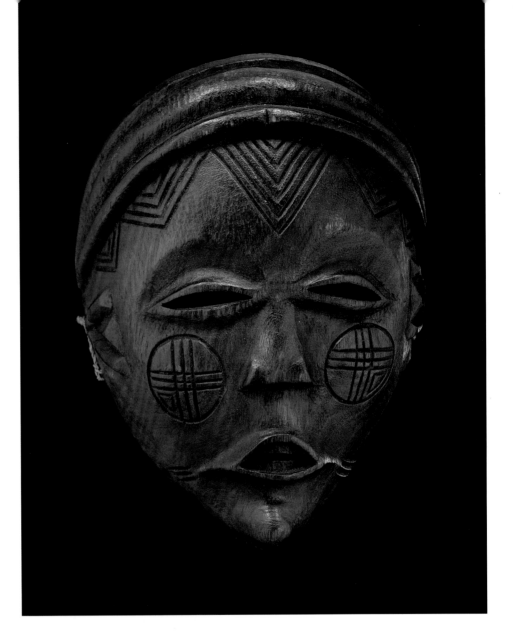

Cat. no. 8

Pwevo or Nalindele (royal woman)
Luvale peoples, Zambia

Wood, plant fiber
H: 26 cm
X2002.33.8

This Luvale mask represents
Nalindele, a version of Pwevo, or
the woman, favored in some areas
of western Zambia. It features large
chijingo, or cross-within-a-circle
scarification rosettes, on the cheeks
and downward-pointing triangular
motifs on the forehead below arched
elements resembling a royal diadem
(fig. 2.3). The elaborate scarification
and diadem are indicative of maturity
and high social rank.

 Versions of the female character
that show attributes of rank, such
as diadems, are created by nonroyal
people to honor the royal class
and to commemorate chieftaincies
and important individuals. Though
representatives of characters with
royal ties, these *makishi* characters
are not exclusive to chiefs and are
performed in association with other
sociable masks. They are not treated
with the exclusivity of royal masks
owned by chiefs, which constitute
a separate category that includes
characters such as Chikungu and
Kayipu (see fig. 3.22).

2.3 Lunda female chief Nyakulenga
is carried during a procession in
honor of her brother Ishindi. She
wears an arched, beaded crown of
a type suggested in some carved
female masks.

PHOTOGRAPH BY MANUEL JORDÁN,
NORTHWESTERN ZAMBIA, 1991.

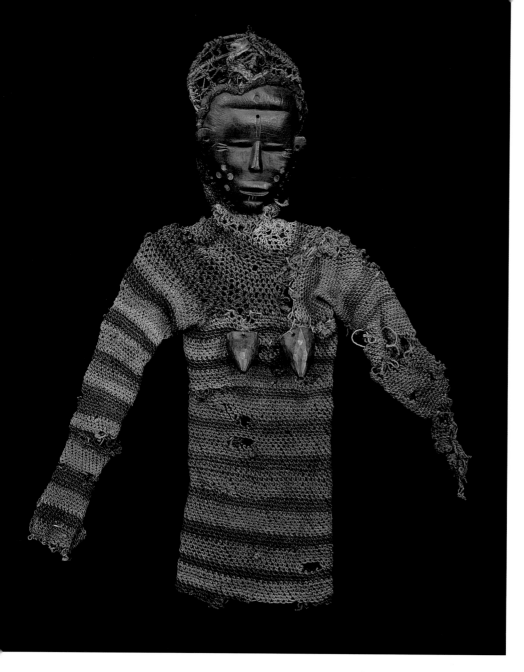

Cat. no. 9

Kashinakaji (old woman)
Luvale or Luchazi peoples,
Zambia

Cordage, wood
H: 100 cm
X2002.33.10

The word *kashinakaji* means "old person," and through this mask, the character Kashinakaji performs as an old woman, articulating the demeanor, moral values, and attributes associated with a revered female elder (fig. 2.4). This mask still retains part of its costume, which is locally referred to as the "body" of the *likishi*. *Makishi* bodies are hand-woven by men with natural fibers or cotton thread. Parts of these woven ensembles may be constructed using a simple loom.

Cat. no. 10 (opposite)

Pwevo or Nalindele (royal woman)
Chokwe or Luvale peoples,
Zambia

Wood
H: 21 cm
X2002.33.7

Scarification marks not only signify status and maturity, they also contain codified information that may be "read" or understood at different semantic levels by different individuals (Roberts and Roberts 1996). The markings on this *likishi* are symbolic representations of some of the forces defining the cosmological views of the peoples considered here. A point of ritual empowerment is implied where the vertical line of the nose crosses the horizontal line of the slit eyes. The resulting cross shape becomes a crossroads, a place of symbolic consequence. The arching scarification lines at the sides of the face activate this design. The two cross-within-a-circle motifs (*vijingo*; sing., *chijingo*) on the cheeks become one sun that is seen both before sunrise (associated with the right side, east, day, and life) and after sunset (associated with the left side, west, evening, and death). The *chingelyengelye*, a powerful symbol, is placed at the top on the forehead, at "noon" when the empowering sun is at its brightest. Within this cyclical view, *vijingo* and *chingelyengelye* are also understood to pivot on their own axes. Masks conceived with this degree of symbolic elaboration may represent royal characters, in this case perhaps a woman of royal blood or an actual female chief.

2.4 A mature Luvale woman engages in a royal performance, illustrating the active role played by women of all ages in ritual and ceremonial life.

PHOTOGRAPH BY MANUEL JORDÁN, NORTHWESTERN ZAMBIA, 1997.

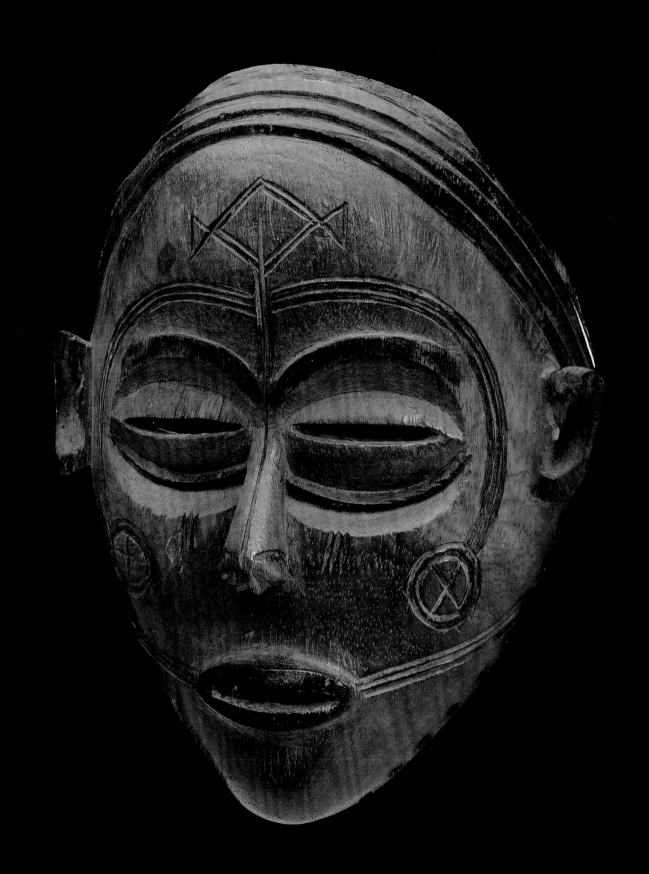

2.5 This photograph of a Pwo masquerader was taken in Angola in the 1960s.

PHOTOGRAPH BY JOSE REDINHA.

Cat. no. 11

Pwo (woman)
Chokwe peoples, Democratic Republic of the Congo or Angola

Wood, raffia
H: 28 cm
X92.130; GIFT OF MRS. SHIRLEY BLACK

Most of the *makishi* featured in this publication are originally from Zambia and are carved or modeled in a southern style distinguishable from equivalent masks made by the same peoples in areas of northern Angola and within the Democratic Republic of the Congo. These two northern-style Chokwe masks are instructive as points of comparison with Zambian examples. Both of these masks represent Pwevo, the female ancestor, or Pwo, as she is known in Angola and the Democratic Republic of the Congo (fig. 2.5). In these masks the typically Chokwe slit eyes, which appear as convex orbits within concave eye sockets, are evident. One of the masks (cat. no. 11) features a distinctive Chokwe treatment of the mouth with pointed, angular teeth, reflecting the nineteenth-century Chokwe practice of filing the teeth. This practice was both a mark of beauty and a sign of cultural belonging. Northern masks are typically deeper than Zambian examples and cover more of a performer's face. The woven wig seen in catalog number 11 is of a type that was worn by Chokwe women until the 1960s. Another type of Chokwe hairstyle is carved as part of the Angolan mask (cat. no. 12).

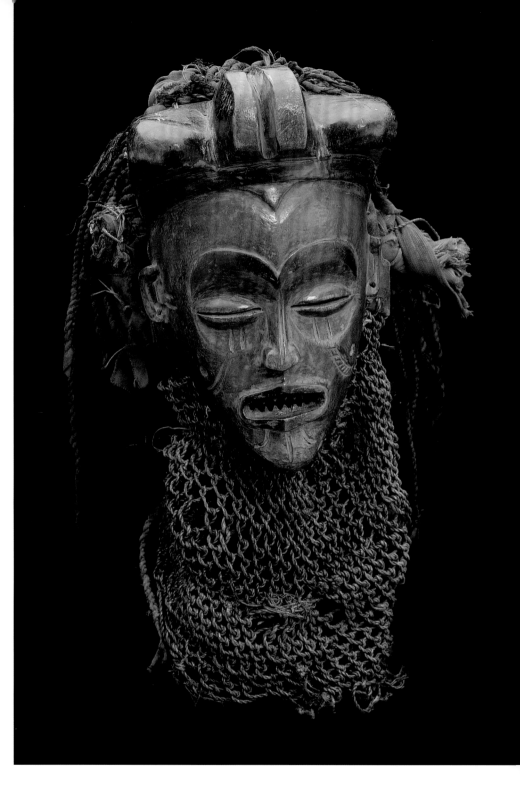

Cat. no. 12 (opposite)

Pwo (woman)
Chokwe peoples, Angola

Wood, raffia string, plant fiber, pigment, cotton, fabric
H: 47 cm
X81.224; ANONYMOUS GIFT

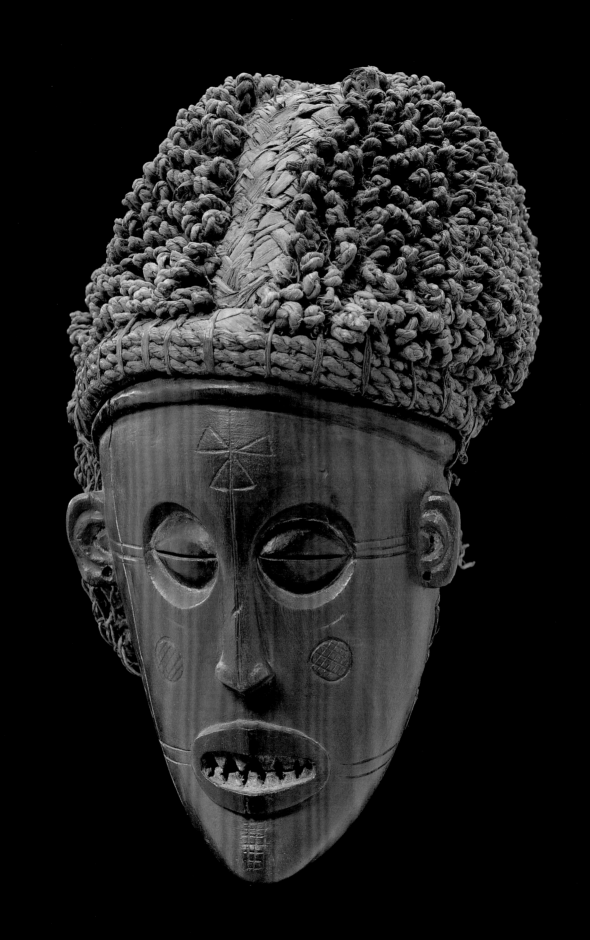

Sociable Male Characters

Cat. no. 13

Sachihongo (royal male)
Mbunda peoples, Zambia

Wood
H: 41 cm
X2002.33.18

Sachihongo, an exclusively Mbunda character, represents a royal male ancestor. This *likishi*, or mask character, has been described as the incarnation of a powerful hunter, a diviner, and a womanizer. Sachihongo is symbolic of maleness, power, fertility, and wealth. The consecutive arched eyebrows, which double as wrinkles on the forehead, are indicative of a serious or even threatening disposition and are characteristic of most Mbunda masks. In this example, they extend downward broadly around the eyes to define the cheeks and form huge eye sockets.

Cat. no. 14 (opposite)

Sachihongo (royal male)
Mbunda peoples, Zambia

Wood
H: 62.5 cm
X2002.33.17

Sachihongo masks are the largest of all the wooden masks created by Mbunda peoples and their neighbors. The large eyes, bulging cheeks, and filed teeth are attributes indicative of the power of this male character. Other physical traits of Sachihongo include a crown of feathers (normally attached to the back of the head), which reflects the character's chiefly origins and supernatural abilities, and a fiber beard.

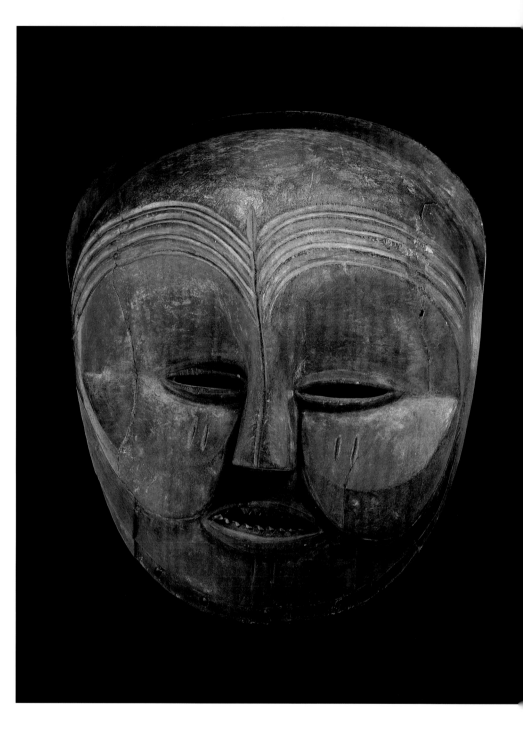

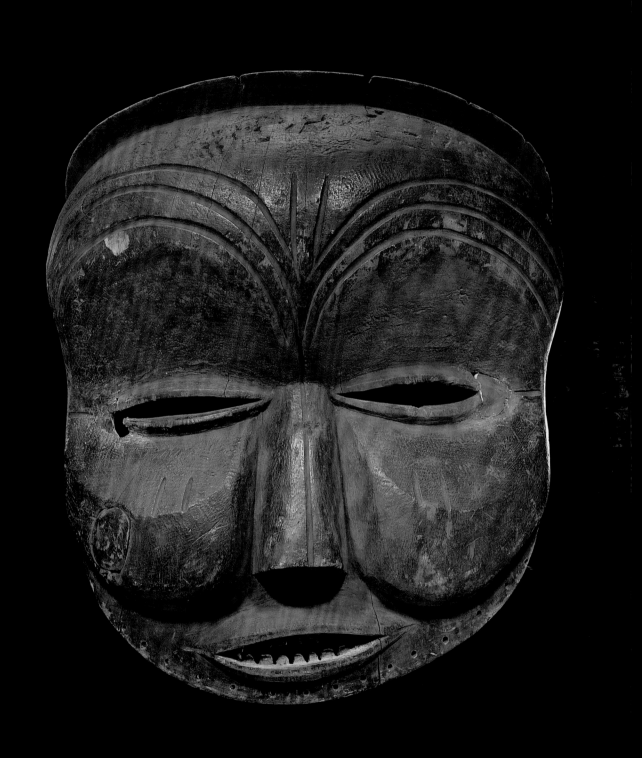

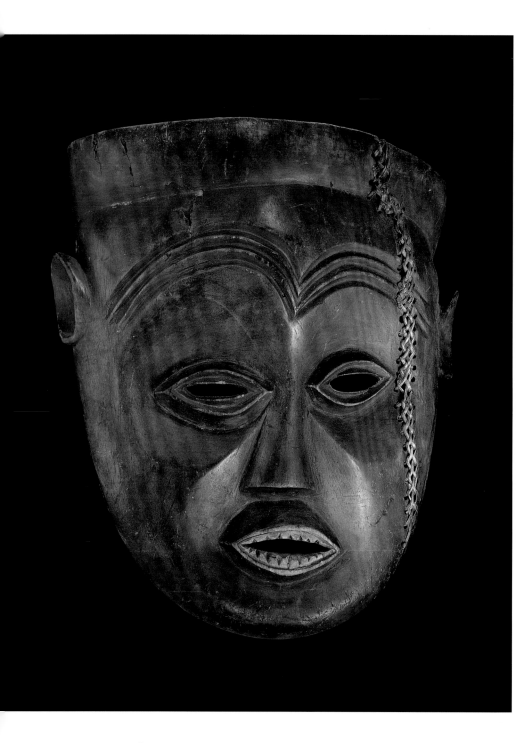

Cat. no. 15

Sachihongo (royal male)
Mbunda peoples, Zambia

Wood
H: 33 cm
X2002.33.15

A split down the left side of this
Sachihongo mask was repaired by
making numerous small holes on
either side of the break and tightly
lacing the two parts together with
cane. Wooden masks are normally
commissioned from professional
carvers and are thus valuable. They
are used in ceremonies and then
carefully stored for future events.
After each performance, masks are
carefully inspected, cleaned, and,
if necessary, repaired. A repair is
not seen as a defect but rather as
a testament to the care given to an
ancestral representation, the length
of its performance history, and its
proper handling.

Cat. no. 16 (opposite)

Sachihongo (royal male)
Mbunda peoples, Zambia

Wood, nails, plant fiber
H: 48.5 cm
X2002.33.16

The best-known style of Sachihongo
carving features a large, broad,
and usually rounded mask outline
(see cat. nos. 13, 14). A second
style is generally smaller with facial
features confined to a narrower,
often oval, shape. This mask, which
falls within the second category, is
somewhat atypical in that all of the
facial features seem to bulge equally
from the flat, board-like background
plane. The extended crown would
have once held feathers on its back.
Triangular patterns (missing here)
are commonly painted or added to
these arched extensions in the form
of attached paper strips.

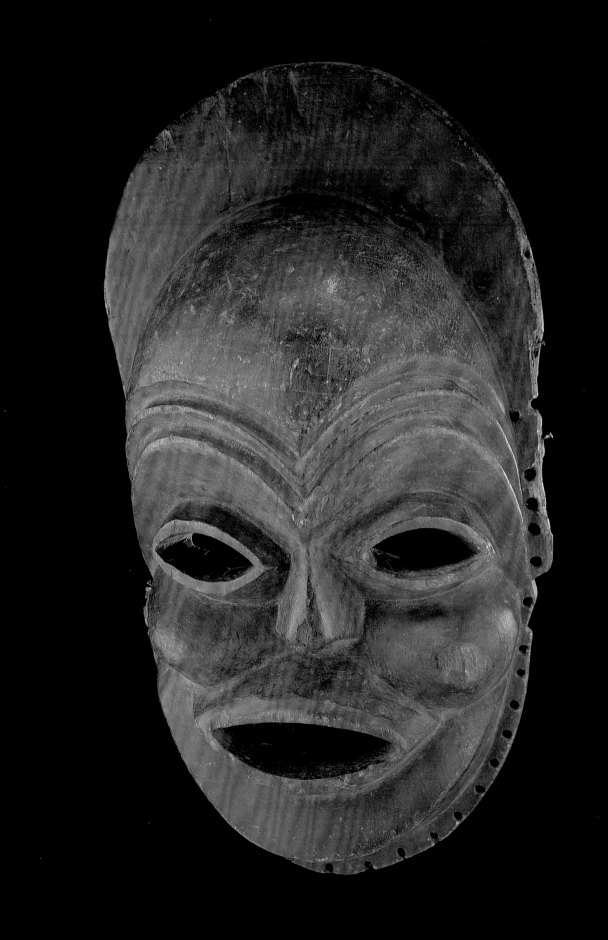

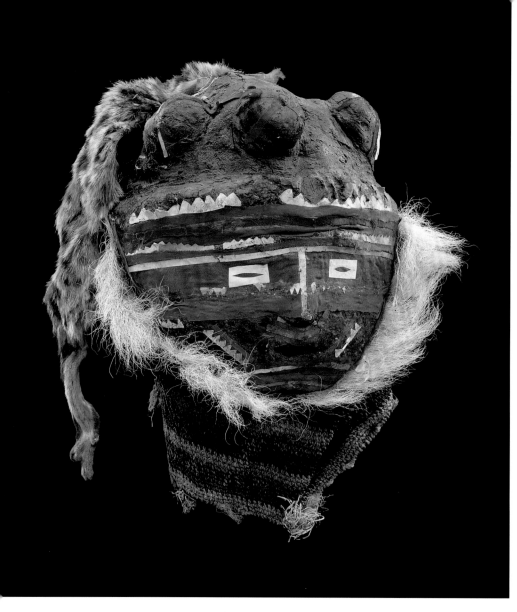

Cat. no. 17

**Chisaluke (tutelary ancestor)
Luvale or Luchazi peoples,
Zambia**

Wood, animal hair, cordage,
cloth, paper
H: 36 cm
X2002.33.20

Chisaluke (pl., Visaluke) is a male
guardian and tutelary spirit of initia-
tion novices. Initiation camps may
have as few as two or more than
a dozen initiates, and ideally there
should be one Chisaluke for each
of them (figs. 2.6, 2.7). This is the
only *likishi* character that is found
in multiples. Visaluke appear during
the last two weeks of initiation right
before the graduation ceremony and
the reintroduction of the initiates to
society after months of seclusion.
They arrive at the *mukanda* camp to
test what the initiates have learned.
Chisaluke masks are typically
constructed by modeling beeswax
or another resinous material over
a twig and fiber frame. The pelts
of genets (small evasive, nocturnal
mammals related to civets) are
attached to the headdress to
symbolize the powers of invisibility
associated with this ancestor. Three
supernaturally charged lobes on the
forehead help distinguish Chisaluke
from other male *makishi* made of
resin with similar headdresses.

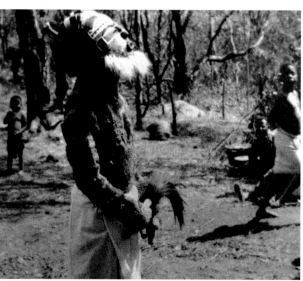

2.6 Chisaluke, the guardian
ancestor, is so appreciated that he
is carried aloft on the shoulders of
those attending the pictured Luchazi
mukanda graduation ceremonies.
Chisaluke and a handful of other
makishi are routinely treated as
heroes.

PHOTOGRAPH BY MANUEL JORDÁN,
NORTHWESTERN ZAMBIA, 1993.

2.7 This photograph of a Chisaluke
likishi was taken by anthropologist
Victor Turner and reproduced
in his important study of Lunda
Ndembu ritual and ceremonial life
in northwestern Zambia *The Forest
of Symbols*, published in 1967.

Cat. no. 18

**Chileya or Chiheu
(guardian ancestor)
Chokwe or Luvale/Lwena peoples,
Angola or Zambia**

Bark, paper, fabric, cotton,
fiber, wood, paint
H: 26.7 cm
X76.297; MUSEUM PURCHASE

Chileya or Chiheu is another male
guardian and tutelary spirit of the
mukanda initiation camp. Similar
to Chisaluke (see cat. no. 17) in
function, Chileya is, however, active
throughout the initiation process
and is sometimes the first mask to
appear at *mukanda*. As with Chisa-
luke, a Chileya *likishi* is normally
modeled with resin over a twig and
fiber frame. Strips of colored cloth
or paper are added to the surface of
the mask to highlight facial features
or represent different designs.
Chileya is sometimes described as
an older male, a fool, or both. These
descriptions fit the range of behav-
iors displayed by the character while
performing lively dances. Chileya's
hair is supposed to be understood
as gray, thus cotton or the pelt of
an animal with a white stripe, such
as a colobus monkey, is attached to
its head.

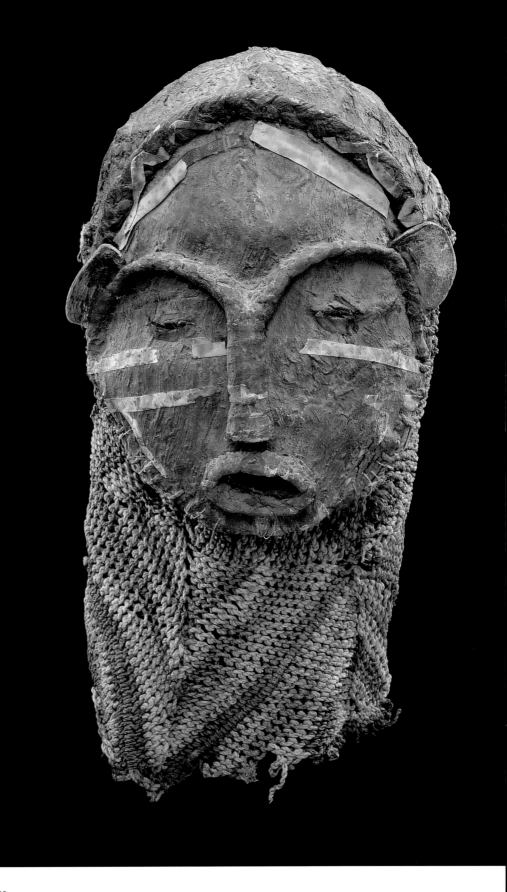

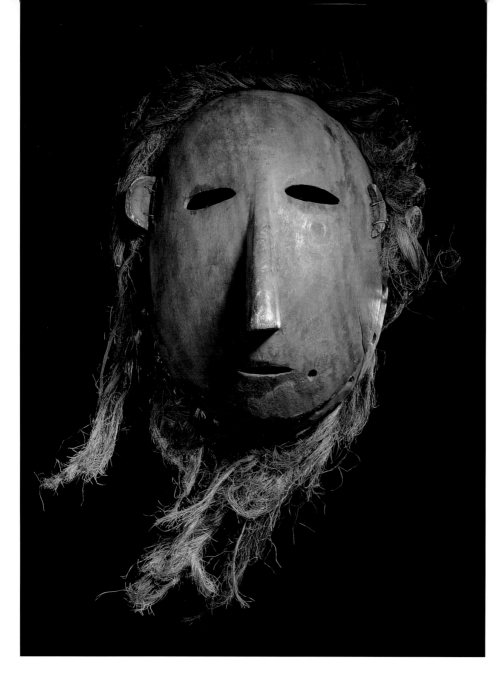

Cat. no. 19

Katoyo or Chindele (foreigner)
Ngangela or Mbunda peoples,
Angola or Zambia

Wood, plant fiber, paint
H: 36 cm
X2002.33.13

Part of the educational strategy of masquerades is to allow the definition of a character to arise from contrast with the physical and performative attributes of other *makishi*. In this case, Katoyo or Chindele, who represents an outsider or a white person, has rather plain facial features with a prominent, long pointy nose (fig. 2.8). The holes that appear on either side of the disproportionately small mouth originally contained fibers or animal hair to suggest the abundant facial hair attributed to white men. Although the simplified forms of this mask are subtle and elegant, the intention of the carver was to parody the physical characteristics of a foreigner.

Cat. no. 20 (opposite)

Katoyo or Chindele (foreigner)
Ngangela or Mbunda peoples,
Angola or Zambia

Wood, rubber, cordage, beads, hair
H: 37 cm
X2002.33.12

This Katoyo or Chindele *likishi* with its rectangular face is representative of masks documented in southeastern Angola among Ngangela peoples and their neighbors (Kubik 1993). What initially might appear to be incised arched eyebrows are actually forehead wrinkles, a typical Mbunda stylistic convention used to impart expressivity to mask characters. In this case, the abundant, straight hair recalls that of some Europeans or foreigners. The tufts of facial hair on either side of the mouth are intended as a mustache. Rectangular masks of this type are exceptionally rare in museum collections.

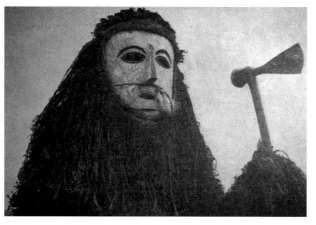

2.8 This Katoyo or Chindele *likishi* appears in a style favored in southern Angola.

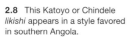
PHOTOGRAPH BY JOSE REDINHA, ANGOLA, 1960S.

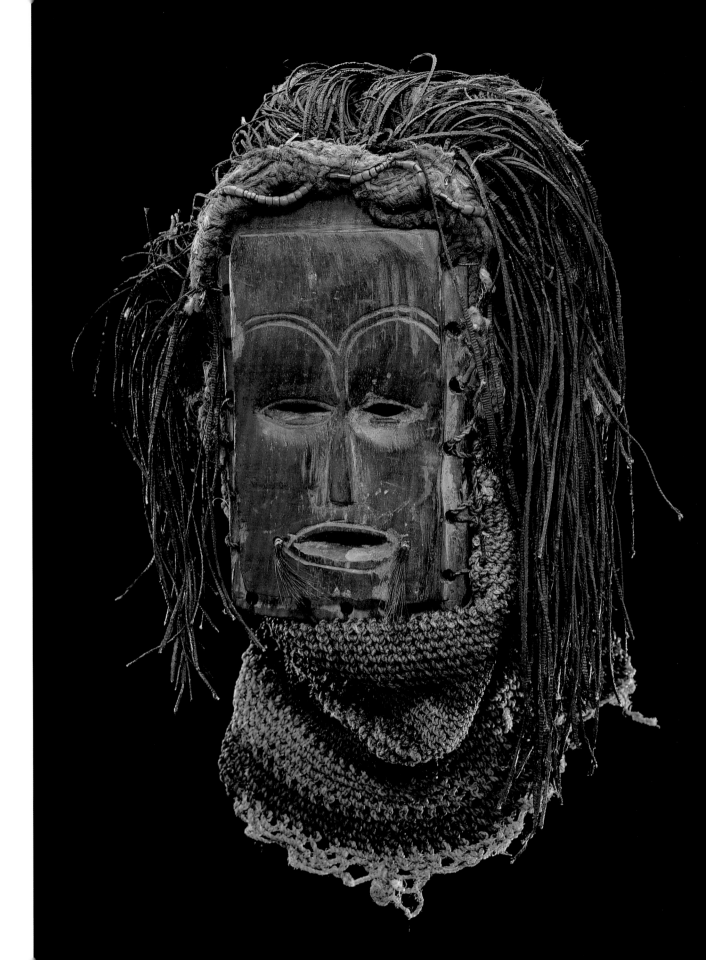

Cat. no. 21

Katoyo or Chindele (foreigner)
Ngangela or Mbunda peoples,
Angola or Zambia

Wood
H: 24 cm
X2002.33.11

This Katoyo or Chindele mask is
carved with an outer ridge that
would have once supported an
elaborate coiffure behind its top
edge and a fiber beard attached
to the holes at the bottom. The
typically Mbunda forehead wrinkles
(see cat. no. 20) are incised above
one eye only. These lines have been
extended vertically, directly above
the bridge of the nose, to indicate a
form of scarification mark known as
kangongo, or "tail of the mouse."

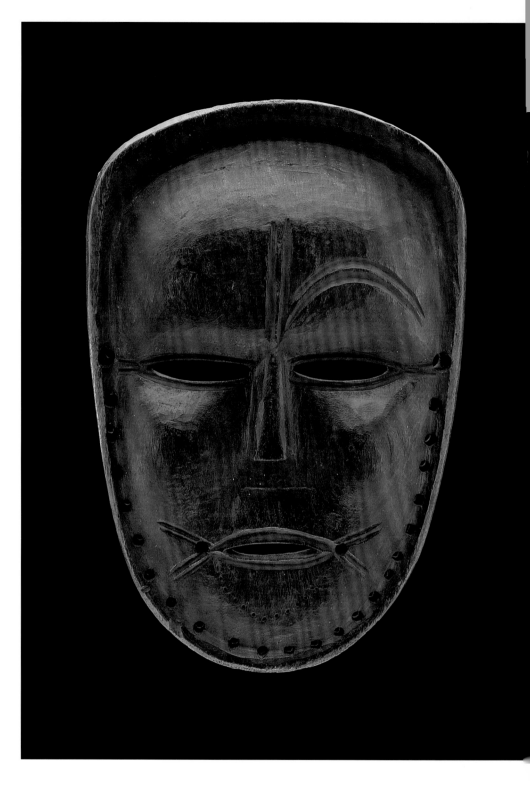

Ambiguous Character

Cat. no. 22

**Katoyo reinterpreted as
Chikungila (ambiguous ancestor)
Mbunda peoples, Zambia**

Wood, plant fiber, cordage
H: 36 cm
X2002.33.14

When shown a photograph of this
mask, two Lunda elders in north-
western Zambia agreed that the
features of the face and the holes for
attaching facial hair at the corners of
the mouth identified this character
as Katoyo, or the foreigner. They
explained, however, that the division
of the mask into halves painted
white and red meant that the
character had been reinterpreted as
Chikungila or Luvwengi. The elders
further remarked that the Chikungila
character "opens its mouth to
devour everything, including goats,
tables, chairs, and even cars." This
is a symbolic reference to the fact
that the character can take anything
at a whim and bring it back to the
mukanda initiation camp. At the
camp Chikungila is believed to
regurgitate everything, turning it
into the food the initiates will eat
during their seclusion. The red and
white sides illustrate a balance or
contrast between the positive (white)
and the negative or ominous (red).
This is consistent with the nature
of ancestral spirits who provide
spiritual support if honored, but who
may also cause illness and calamity
if neglected. This redefined *likishi*
falls within the category of ambigu-
ous characters while illustrating the
semantic flexibility of *makishi* forms.
Originally interpreted as a Katoyo,
a sociable character, the mask was
later reinterpreted as Chikungila, an
ambiguous character, to fulfill the
need for such a character in a par-
ticular *mukanda* where the sociable
one was no longer needed.

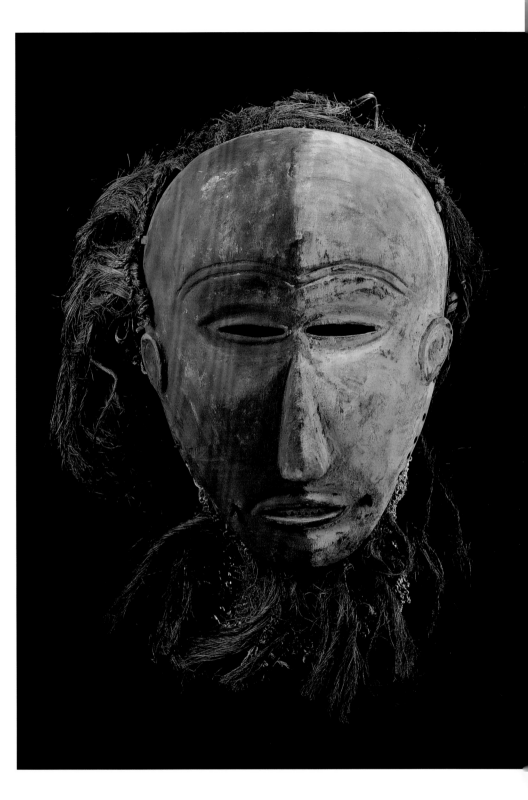

Aggressive Characters

Cat. no. 23

Utenu (angry ancestor)
Luvale peoples, Zambia

Wood, bark cloth, fabric,
paper, hair, resin
H: 55.9 cm
X70.924; GIFT OF DR. AND MRS. JOEL BREMAN

Utenu has an anthropomorphic face
with a flat, keel-shaped headdress
that is usually decorated with
different patterns. This *likishi* clearly
falls within the category of aggres-
sive masks whose main function
is to protect the initiation camp
and novices, both physically and
supernaturally. Utenu is extremely
aggressive in demeanor, chasing
people, casting insults, and making
rude utterances (fig. 2.9). This *likishi*
is called "the angry one," and *kazaye*
(meaning "I am angry") is sometimes
written on the headdress. The mask
is known to run and crash against
bushes or shrubs, thereby demon-
strating its uncontrollable rage. Such
behavioral tendencies are meant
to be intimidating but also serve
to contrast the antisocial behavior
of Utenu with the social, friendly,
and well-mannered demeanor of
characters such as Pwevo.

Cat. no. 24 (opposite)

Mbwesu (protective ancestor)
Chokwe peoples, Angola or
Zambia

Wood, cloth, paint
H: 53 cm
X2002.33.19

This mask represents Mbwesu, a
Chokwe character who is part royal
male and part aggressive or protec-
tive ancestor. The disk protruding
from the mask's chin is interpreted
as a chiefly beard. The elaborate
crown with its arched structural
elements serves as an antenna to
collect powerful cosmic forces on
the head of the character. The trian-
gular patterns painted on the arched
headdress are associated with those
on the skin of the Gabon viper and
with the scales of the pangolin, a
scaly anteater found in Africa. The
Chokwe attribute supernatural pow-
ers to both creatures and associate
them with creation and ancestry.
Mbwesu's headdress mimics the
crowns of Chokwe chiefs, which are
similarly constructed and decorated
with patterns in paint or beadwork.

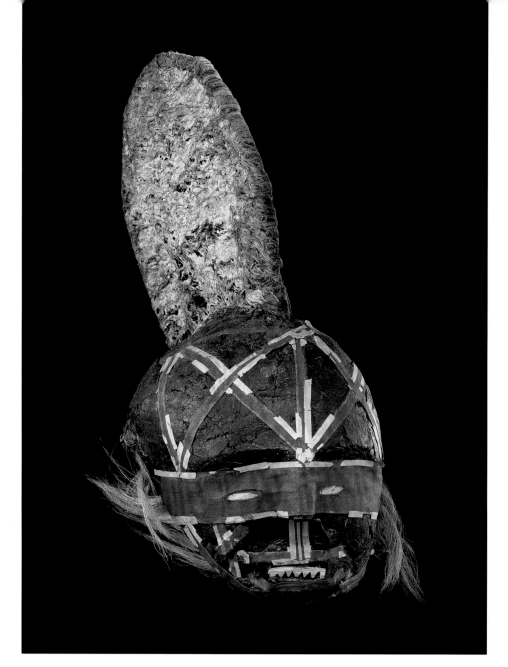

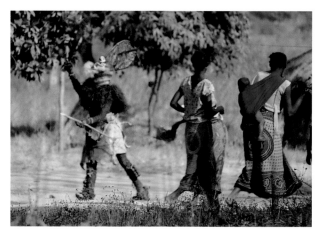

2.9 Utenu, "the angry one," utters
insults while passing by Lunda
women and children.

PHOTOGRAPH BY MANUEL JORDÁN,
NORTHWESTERN ZAMBIA, 1991.

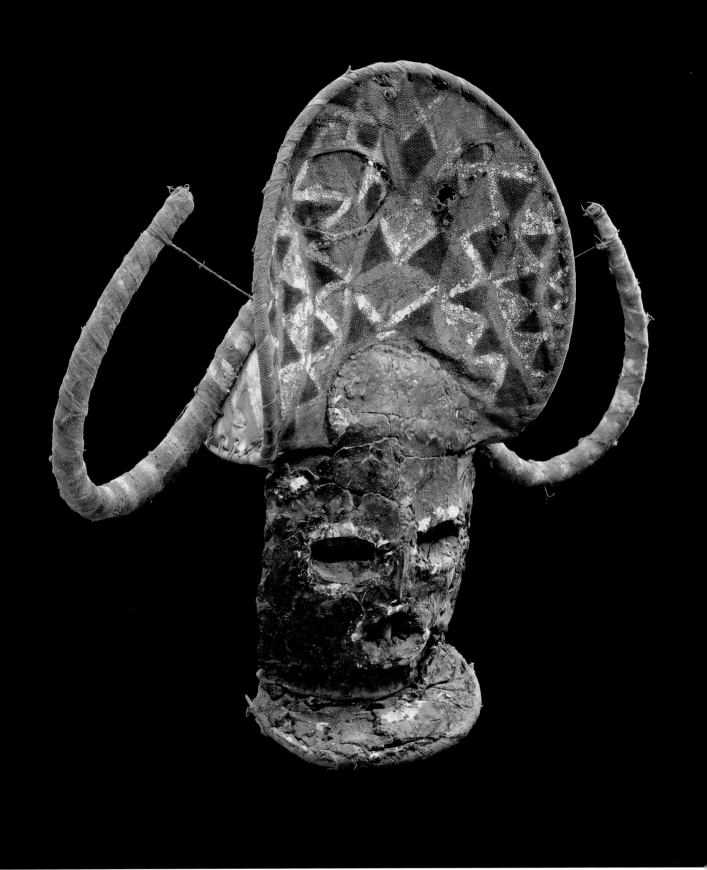

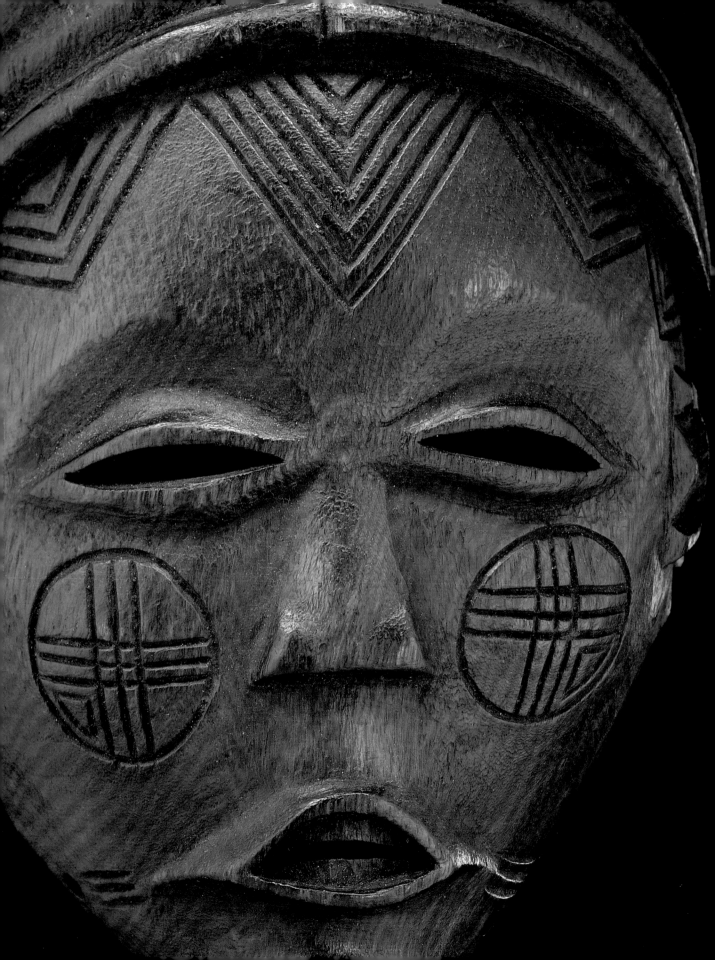

Makishi in Performance
A Selection of Characters with Descriptions and Attributes

This section expands upon the character-type categories represented in the preceding catalog by *makishi* in the Fowler Museum collection and reflects the broader corpus of mask characters within which the Museum's masks were conceived. The character categorizations, physical descriptions of *makishi*, and defined behavioral attributes presented here are, with few exceptions, based on actual *makishi* performances and information gathered from 1991 to 1993 and in 1997 and 2004 in northwestern Zambia. *Makishi* physical descriptions are meant to help in identifying different character types. It should be noted that in any masquerade tradition there is significant room for variation. The behaviors, physical characteristics, and interpretations documented here may vary regionally or in response to social transitions that may require a mask character to look or behave differently in order to comment upon or address impending change through performance.

Sociable Characters

3.1

Character
Pwevo, Pwo, Mubanda

Type
Sociable (female)

Peoples
Chokwe, Luvale, Luchazi, Lunda, Mbunda

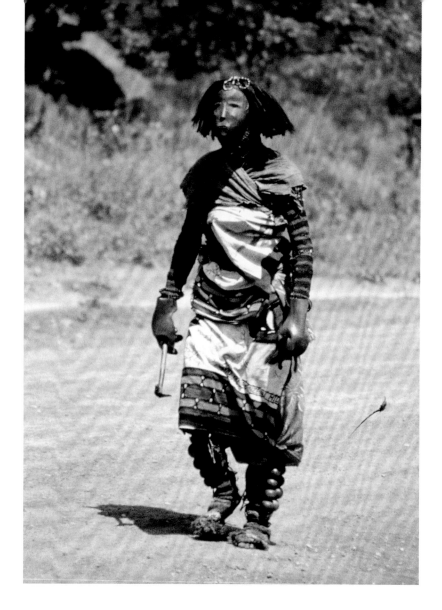

Chokwe peoples, northwestern Zambia, 1991

Description The anthropomorphic mask of Pwevo (also known as Pwo or Mubanda) can be carved from wood or made from ephemeral materials. It may include elaborate facial scarification details applied in the form of strips of paper or carved in relief in the case of wooden masks. The mask performer wears a fiber coiffure that is attached to the mask and imitates one of several hairstyles favored by women. Beads and metal earrings are often added. In addition the performer is clothed in a full-body, knitted, fiber or cotton costume and lengths of imported, printed textiles that serve as a wraparound skirt or dress. A dance bustle and ankle rattles are also worn to emphasize dance movements. Pwevo may hold a small adze, axe, or fly whisk.

Attributes Pwevo represents a primordial female ancestor. While this character does appear at ceremonial occasions—including the investiture of chiefs (where "she" may lead processions) and political rallies—Pwevo is best known in association with *mukanda* initiations. "She" appears numerous times during initiation events to heighten the enjoyment of those celebrating. While danced and performed by men, Pwevo serves as a symbolic emissary to women, particularly the mothers of initiates. This *likishi*, or mask character, represents the beauty, morality, and abilities of women and routinely escorts male *makishi* such as Chisaluke (see 3.7) in order to present an image of gender interdependence. The performance of Pwevo imitates dances steps associated with women. This is the quintessentially accessible, or sociable, mask type.

3.2

Character
Mwana Pwevo, Mwana Pwo, Mwana Mubanda

Type
Sociable (female)

Peoples
Chokwe, Luvale, Luchazi, Lunda, Mbunda

Luvale peoples, northwestern Zambia, 1997

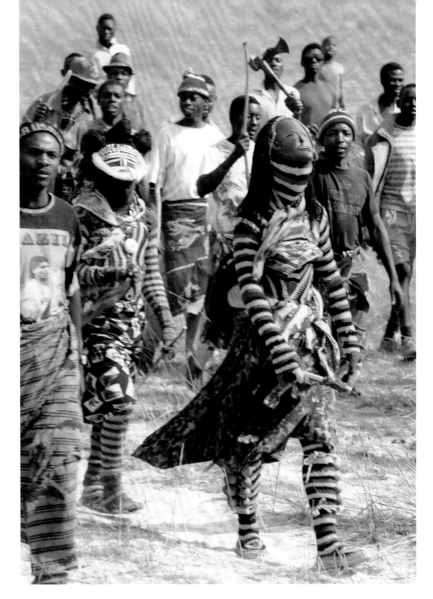

Description The physical attributes of Mwana Pwevo are essentially the same as those of Pwevo (see 3.1). In order to reflect the physical appearance of a young woman, however, Mwana Pwevo (also known as Mwana Pwo and Mwana Mubanda) may wear a modern hairstyle and display few or no facial scarification marks.

Attributes Mwana Pwevo literally means "young woman." The symbolic and behavioral attributes of this character are practically identical to those of Pwevo, although the younger female may epitomize more modern values or morals. In some areas, however, the names Pwevo and Mwana Pwevo are interchangeable.

3.3

Character
Chiwigi

Type
Sociable (female)

Peoples
Chokwe, Luvale, Luchazi, Lunda, Mbunda

Lunda peoples, northwestern
Zambia, 1991

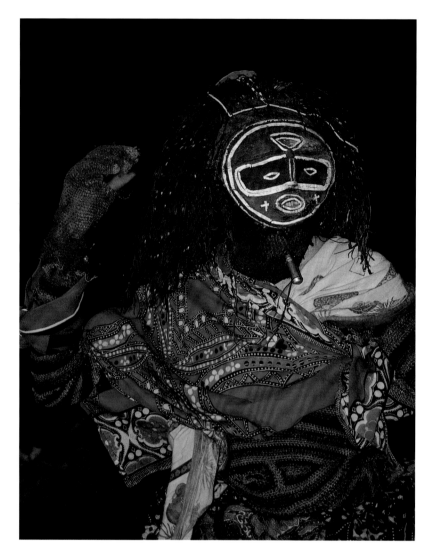

Description Chiwigi shares much of the appearance and many of the same attributes as Mwana Pwevo (see 3.2). The only distinguishing feature is Chiwigi's long, straight, abundant (wig-like) hair. The name Chiwigi is in fact derived from the English word "wig."

Attributes Chiwigi may stress the attitude, demeanor, and sometimes the vanity displayed by some young women. This contrasts with the behavior and character of more mature and accomplished Pwevo (see 3.1).

3.4

Character
Lweji

Type
Sociable (royal female)

Peoples
Chokwe, Lunda

Chokwe peoples, northwestern
Zambia, 1997

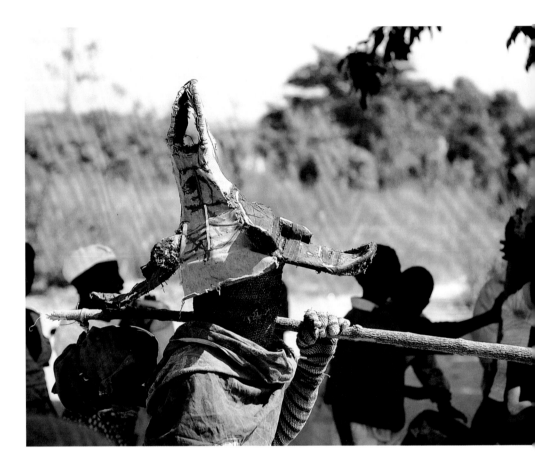

Description The anthropomorphic Janus-faced mask of Lweji is made from ephemeral materials. The two faces of the mask project in opposite directions from a shared central arched headdress that represents a crown. Facial features and decorative motifs are applied in the form of strips of colored paper. The mask performer wears a full-body, knitted, fiber or cotton costume and lengths of imported or printed textiles that serve as a wraparound garment. Lweji may hold a stick over the shoulder tied at its end with bundles of clothes.

Attributes Lweji represents the celebrated and well-documented Lunda female chief of the same name who lived at the beginning of the seventeenth century. In performance her elegant demeanor, careful steps, and assertive tone of voice reflect her royal status. She holds a stick with bundles of cloth to indicate her long journey from the world of the dead (and the past) to the world of the living. This *likishi*, or mask character, is typically Chokwe, although it was field documented (see photograph) at a Lunda *mukanda* initiation in northwestern Zambia where a Chokwe initiation leader, Mukuta Samukinji, was hired to oversee the camp and all the *makishi* that were created for it. Versions of Pwevo (particularly those carved in wood) created by related peoples, however, sometimes include elaborate diadems or small, arched crown-like elements, which may indicate that the character represented is a female chief or a woman with royal associations.

3.5

Character
Chihongo

Type
Sociable (male)

Peoples
Chokwe

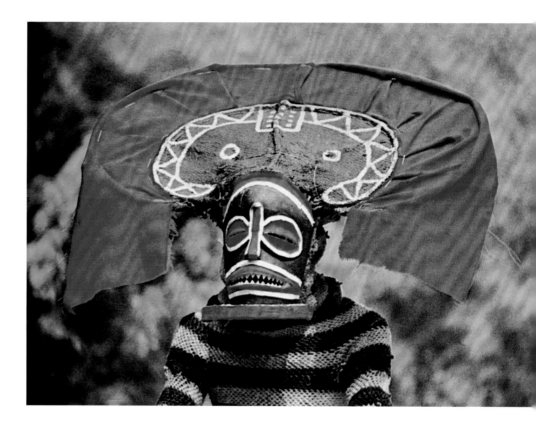

Chokwe peoples, Angola, 1960s
(photographer unknown)

Description The anthropomorphic Chihongo mask is either made from ephemeral materials or carved in wood. A distinguishing element is a disk-shaped beard carved or modeled below the chin. Facial scarification details are added in strips of paper or cloth or carved in relief in the case of some wooden masks. Chihongo wears a crown or high-arched diadem to which feathers are sometimes added. The mask performer wears a full-body, knitted, fiber or cotton costume along with a broad fiber skirt over a frame of bent branches.

Attributes Chihongo represents a Chokwe male spirit of wealth and power, and the disk-shaped beard and crown are reminiscent of those worn by some Chokwe chiefs. This *likishi*, or mask character, may appear in initiations for the sons of Chokwe chiefs, at royal confirmatory ceremonies, or during other events. Chihongo is not aggressive but rather represents an auspicious male spirit made accessible to people through public performances. The Chihongo dance is characterized by a rhythmic swaying of the hips and fiber skirt from side to side. This character is rare in Zambia, where there are no Chokwe chiefs. I have been told, however, that Angolan Chihongo masks have been sent to Zambia to perform in honor of other chiefs.

3.6

Character
Sachihongo, Samahongo

Type
Sociable (male)

Peoples
Mbunda

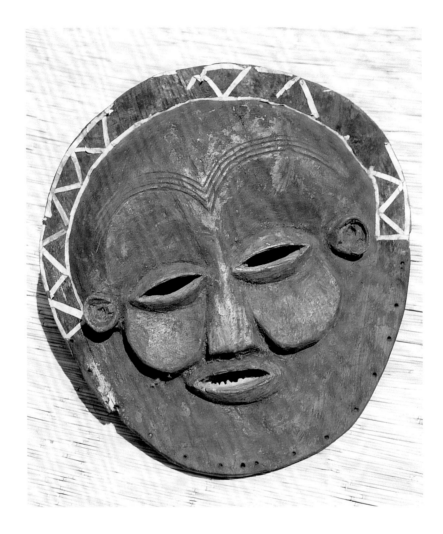

Mbunda peoples, northwestern
Zambia, 1991

Description Sachihongo is carved in wood in a variety of related styles. The most common of these features a large, broad, rounded facial outline with large eyes, nose, and mouth carved in relief. Forehead wrinkles are commonly included in Mbunda masks and take the form of undulating lines incised at the bottom of the forehead above the eyes. Feathers are inserted in holes around the upper ridge of the circular masks, and additional feathers may be attached to the top of the head. A fiber beard is tied to the holes on the bottom ridge of the mask. The mask performer wears a full-body, knitted, fiber or cotton costume and a fiber skirt and neck covering. Sachihongo may hold an axe or fly whisk.

Attributes Sachihongo is the Mbunda version of the Chokwe Chihongo (3.5), the male spirit of wealth and power. Sachihongo, however, seems to have more attributes or symbolic associations and may be described as a chief, a successful hunter, or a diviner. Like other sociable mask characters, Sachihongo is approachable through public performances. As in the case of most other masks, this *likishi* stresses fertility through dance by twirling the hips to create a "fanning" motion of the fiber skirt.

3.7

Character
Chisaluke

Type
Sociable (male)

Peoples
Chokwe, Luvale, Luchazi, Lunda, Mbunda

Mbunda-Chokwe peoples, northwestern Zambia, 1992

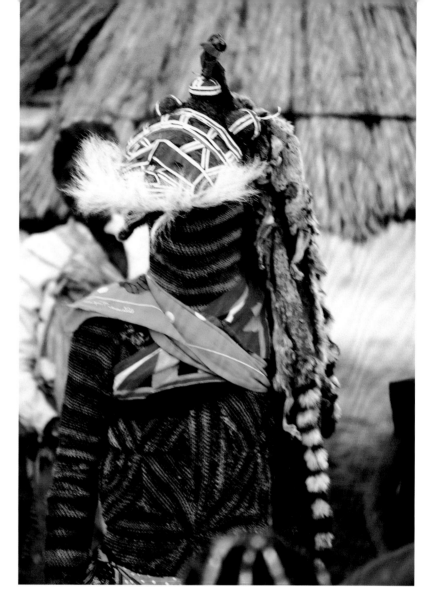

Description The anthropomorphic face mask representing Chisaluke is usually constructed from ephemeral materials but is also sometimes carved in wood. Facial features are carved or applied using paper or strips of cloth. A fiber beard is tied or glued to the chin area of the mask. The main distinguishing features are three small, round lobes extending from the forehead—the central lobe containing a plug—and the small animal pelts attached to the head of the mask to serve as hair. The mask performer wears a full-body, knitted, fiber or cotton costume and shorts instead of a skirt. A *fuifui*, or phallic appendage, may also be worn.

Attributes A male tutelary spirit principally associated with the *mukanda* initiation, Chisaluke is the only mask character to appear in multiples within an initiation camp. Each initiate is supposed to have his own Chisaluke as a tutelary ancestor. Chisaluke masks appear during the final two or three weeks of an initiation, and they take an active role in enhancing the dancing skills of initiates before their graduation. Chisaluke's dances vary according to the occasion, and the mask character takes on different behavioral attitudes to complement specific *mukanda* events. Chisaluke is one of several characters in the sociable category who wear the *fuifui* phallic appendage in specific dances to stress fertility.

3.8

Character
Chileya, Chiheu

Type
Sociable (male)

Peoples
Chokwe, Luvale, Luchazi, Lunda, Mbunda

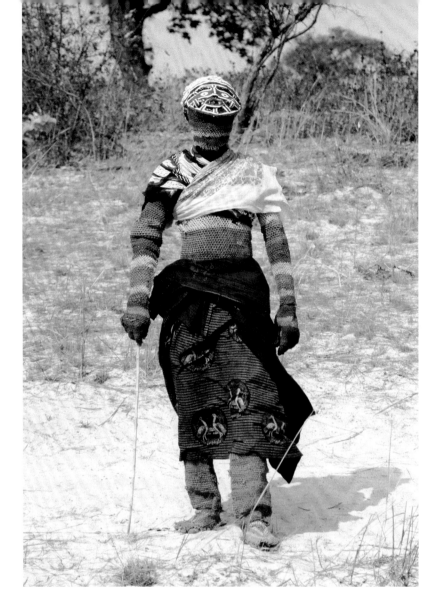

Luvale peoples, northwestern Zambia, 1997

Description Chileya (also know as Chiheu) is similar in appearance to Chisaluke (see 3.7), although lacking the latter's forehead lobes. Chileya's hair, generally made by applying cotton or feathers to the mask's cap, is also different from that of Chisaluke. The anthropomorphic face mask of Chileya is usually constructed from ephemeral materials but can also be carved in wood. Facial features are applied in the form of paper or strips of cloth, or they are carved in the case of wooden masks. The mask performer wears a full-body, knitted, fiber or cotton costume and may wear shorts instead of a skirt. The *fuifui*, or phallic appendage, is also sometimes worn by this mask character.

Attributes Chileya is another male tutelary ancestor who appears mainly in the context of events connected with *mukanda* initiation. The performance of Chileya is related to that of Chisaluke, but Chileya does not have a direct relationship with the initiates or their learning process. The behavior and performance of Chileya vary according to specific ceremonies. Part of the character's performance behavior may seem erratic or foolish, but that is just one aspect of the persona of this *likishi*, or mask character. Although Chileya has sometimes been described as the "fool" or as an "old man," other characters specifically epitomize foolish behavior (Ndondo; see 3.10) and old age (Kashinakaji; see cat. no. 9).

3.9

Character
**Katoyo, Simonda
(also Simonde)**

Type
**Sociable (foreigner
or outsider)**

Peoples
**Chokwe, Luvale, Luchazi,
Lunda, Mbunda**

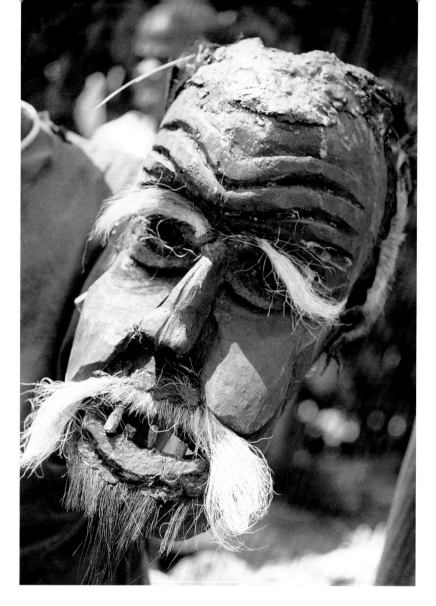

Mbunda peoples, northwestern
Zambia, 1997

Description This anthropomorphic mask may be either carved in wood or made with ephemeral materials. Its facial features typically include a long or pointed nose and exaggerated teeth, which may be carved or formed using bones, animal teeth, or sticks. Facial hair is often attached near the mouth, and facial scarification details are often included. The performer wears a full-body, knitted, fiber or cotton costume and may wear a *fuifui*, or phallic appendage.

Attributes Katoyo represents a European, white person, foreigner, or outsider. Versions of the outsider include Simonda (shown in the photograph) and representations of neighboring peoples believed to be "uncivilized," such as the culturally unrelated Lozi, who share territories (mainly with the Mbunda) in western Zambia. Katoyo is thus intended as a caricature of "the other" and ridicules the "awkward" features and inappropriate behavior of outsiders. Its performance, however, is similar to that of such *makishi* mask characters as Chileya (see 3.8) and Chisaluke (see 3.7), and like these characters, it is carried on the shoulders of men during *chilende,* the *mukanda* initiation graduation performances, where it engages in sexually explicit dances featuring its *fuifui*, or phallic appendage. This may relate directly to what is perceived as the inappropriate sexual behavior of foreigners.

3.10

Character
Ndondo

Type
Sociable (male fool)

Peoples
Chokwe, Luvale, Luchazi, Lunda, Mbunda

Lunda peoples, northwestern
Zambia, 1992

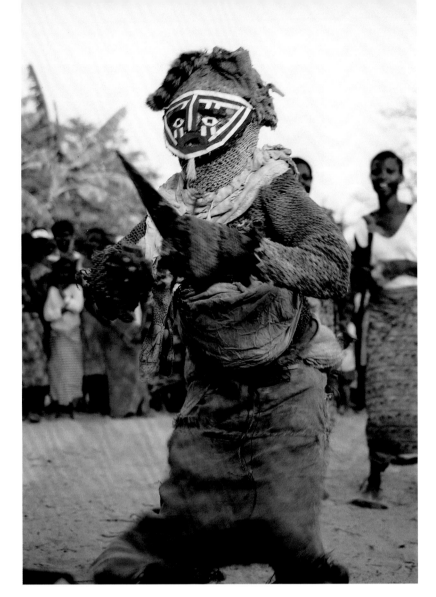

Description　Ndondo takes the form of a simple anthropomorphic mask. The performer of this character is usually a young initiated boy or a short adult male who wears old, torn clothes and is costumed to give the appearance of having a swollen abdomen.

Attributes　This *likishi*, or mask character, typically threatens the audience with a knife and begs for money. Ndondo represents an ill-mannered fool who is intended to contrast with well-mannered characters such as Pwevo.

3.11

Character
Ngulu

Type
Sociable (animal)

Peoples
Chokwe, Luvale, Luchazi, Lunda, Mbunda

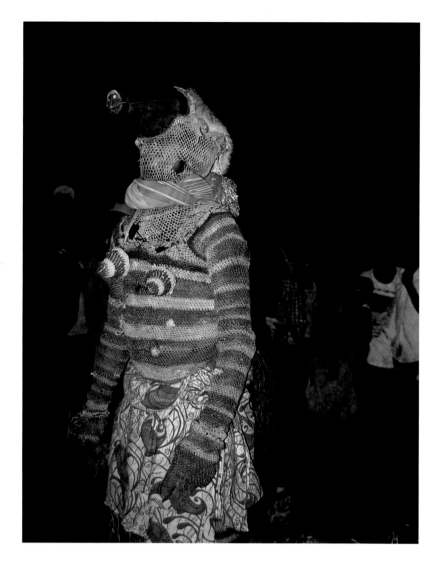

Luvale peoples, northwestern
Zambia, 1992

Description This mask character is normally carved in wood, although fiber versions are also made. Ngulu masks are generally naturalistic representations of a pig. Animal fur (generally monkey but also genet or mongoose) is attached to the top of the head. Some examples have a fiber coiffure or cap. The mask performer wears a full-body, knitted, fiber costume similar to that worn by anthropomorphic *makishi*, sometimes including false breasts. Ngulu may hold a fly whisk or a ceremonial axe or adze during performances.

Attributes Ngulu represents the domestic pig. Rarer variations of the character may include a wild pig or an aardvark, both of which have similar physical and behavioral attributes, although they differ in their symbolic associations. The pig dances on the ground (with the mask performer on hands and knees) or standing, imitating the uncontrollable behavior of the animal, which is to be contrasted with the proper or civilized behavior of such anthropomorphic types as Pwevo.

3.12

Characters
**Ndumba or Tambwe
with Mbachi**

Types
Sociable (animals)

Peoples
**Mbunda, Luchazi, Luvale,
Ngangela**

Mbunda peoples, northwestern
Zambia, 1997

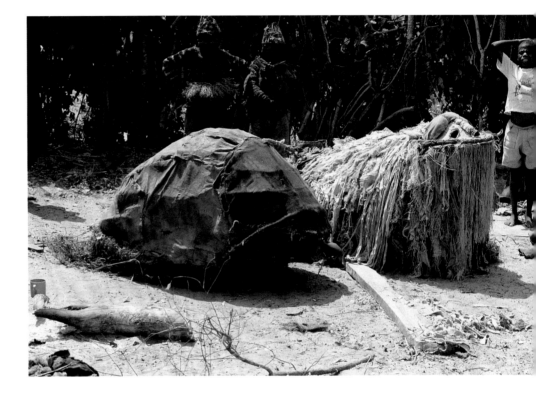

Description Various animals—including Ndumba or Tambwe (lion; at right of photograph),
Mbachi (tortoise; at left of photograph), Munguli (hyena), and others—are constructed by creating
a frame of bent twigs and branches and adding bark, burlap, or similar materials to model the
body. The animal forms are hollow, and a performer (sometimes two) hides inside the structure
to animate the creature. The mouths or heads of these animal characters are often articulated.

Attributes These animal forms are primarily associated with the Mbunda of western Zambia
and the Ngangela in Angola, although Luvale and Luchazi examples exist as well. These are
not animal face masks with full-body, knitted suits, which are performed in an upright position.
Instead, they take the overall body shape of various animals and are performed on hands and
knees on the ground. The animals appear in the context of *mukanda* initiations and during the
confirmatory ceremonies of chiefs. These entertaining animal masquerades relate to proverbs
and episodes that form part of the corpus of traditional stories.

Ambiguous Characters

3.13

Character
Katotola, Ngondo

Type
Ambiguous

Peoples
Chokwe, Luvale, Luchazi, Lunda, Mbunda

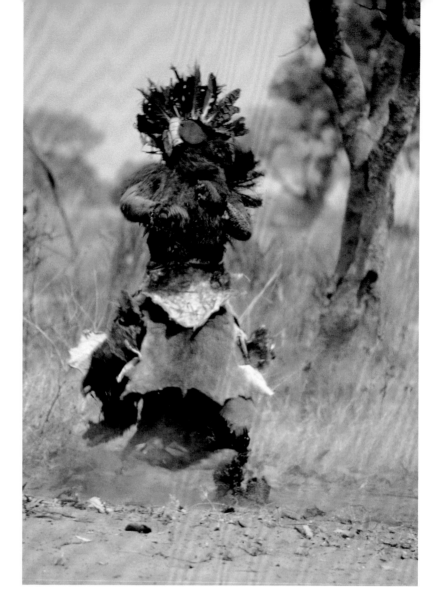

Chokwe peoples, northwestern Zambia, 1991

Description The face of Katotola (also known as Ngondo) is made of knitted fiber or cotton to which large eyes (often red and white) are attached. A distinctive headdress of feathers, bunched within a round fiber frame, is also worn. This mask is similar to Kapalu in the royal category (see 3.24) but wears a shorter crown of feathers. Another style of Katotola mask, favored by some Lunda and Chokwe, lacks the feathers and includes a small structural arch ranging from the front to the back of the head. The performer wears a full-body, knitted, fiber or cotton costume and may wear shorts instead of a skirt. Katotola generally holds two wooden sticks.

Attributes The version of Katotola shown here is not to be confused with the aggressive mask of the same name (related to Mupala), which has a large arched headdress. Katotola's small feathered headdress is similar to those worn by diviners during exorcism rituals. This *likishi*, or mask character, is a protective spirit. The mere presence of Katotola suggests supernatural powers, however, causing people to keep their distance. It is not necessary, therefore, for this mask character to chase spectators away. Katotola plays *kukuwa* sticks, which are referred to as the "bones of the ancestors," and is said to be able to find things that are hidden or invisible.

3.14

Character
Kalulu, Bwanda, Kashinshi

Type
Ambiguous

Peoples
**Chokwe, Luvale, Luchazi,
Lunda, Mbunda**

Mbunda-Chokwe peoples,
northwestern Zambia, 1992

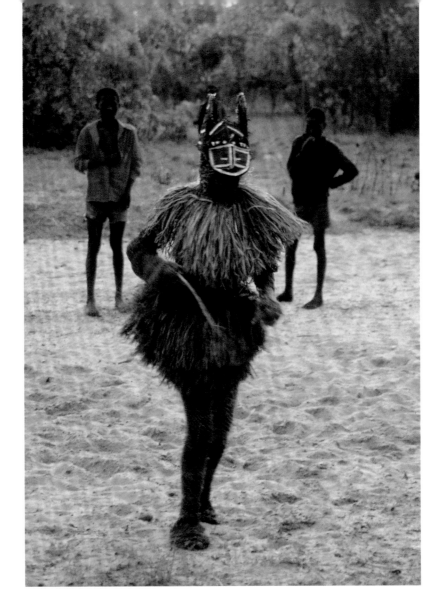

Description This small mask has anthropomorphic facial features with distinctive hare-like ears projecting upward from the sides of its head. The mask is made from ephemeral materials, and the performer wears a full-body, knitted, fiber or cotton costume with a fiber skirt and neck covering. Kalulu (also known as Bwanda and Kashinshi) may hold an axe or a small weapon.

Attributes Kalulu is known as "the hare," and like that speedy and resourceful animal, this mask character is a trickster spirit with supernatural powers. As an ambiguous figure, Kalulu pretends to steal things, including babies who may be briefly snatched from their mothers. Another version of Kalulu—manifested in anthropomorphic form, although actually a spirit being and trickster—appears in the context of divination.

3.15

Character
Ngaji

Type
Ambiguous

Peoples
Chokwe, Luvale, Luchazi, Lunda, Mbunda

Lunda peoples, northwestern Zambia, 1991

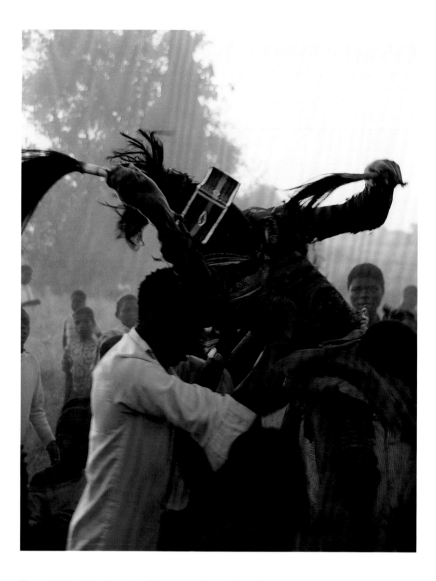

Description The head and face covering of Ngaji are made of knitted fiber or cotton. The facial features of the character are defined by a flat, rectangular band (made of wood, cardboard, or a strip of metal), which is attached horizontally across the middle of the face covering. The eyes and mouth are suggested by white paper applied over the red background of the band. A distinctive headdress of feathers is bunched within a round fiber frame and resembles that worn by some examples of Katotola (Ngondo; see 3.13). The performer wears a full-body, knitted, fiber or cotton costume and may wear shorts instead of a skirt. A *fuifui*, or phallic appendage, is sometimes also worn.

Attributes Ngaji is the most abstract-looking character in the ambiguous category. Although physically this character may have more in common with masks in the ambiguous category, Ngaji's performance and attributes are closely related to those of such sociable masks as Chileya (see 3.8) and particularly Chisaluke (see 3.7). Like Chisaluke, Ngaji has a specific role within *mukanda* initiation and appears only during the last few days to serve as a judge of the initiates and the final initiation events. For the *mukanda* graduation ceremonies, Ngaji, like Chisaluke and Chileya, is carried on a man's shoulders into the performance arena. These mask characters are treated as heroes and received by large crowds who celebrate the successful completion of *mukanda*-related events.

Aggressive Characters

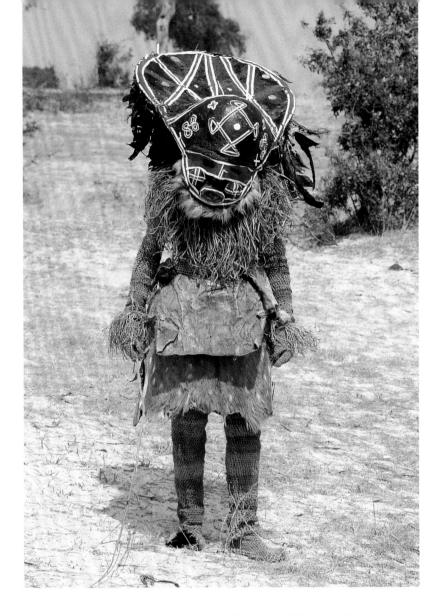

3.16

Character
Mupala

Type
Aggressive

Peoples
Chokwe, Luvale, Luchazi, Lunda, Mbunda

Luvale peoples, northwestern Zambia, 1997

Description Mupala is a smaller version of the royal *likishi*, or mask character, Kayipu (see 3.22) and has a similar, but smaller, headdress with feathers on the back. It also has an anthropomorphic face with exaggerated mouth, nose, eyes, and cheeks, but it lacks the feather, figurine, or small decorative panel that appears atop the forehead of Kayipu. The performer of the Mupala *likishi* wears a full-body, knitted, fiber or cotton costume and an animal pelt as a skirt. Mupala holds a tree branch, a machete, or another form of weapon. This mask is normally made of ephemeral materials, but wooden examples are carved on occasion.

Attributes Mupala is the "lord" and main guardian spirit of the *mukanda* initiation camp but also appears in confirmatory ceremonies for chiefs. This *likishi* is an aggressive character, and its large size and exaggerated facial features make it more intimidating than other masks in this category. Its general behavior and dance are similar to those of Chikuza (3.20) and Kalelwa (3.19). Mupala is made by all the related peoples of western and northwestern Zambia but is generally perceived as being Luvale or Luchazi in origin. Other aggressive masks are closely related in morphology to Mupala.

3.17

Character
Litotola, Katotola

Type
Aggressive

Peoples
Luvale/Lwena, Luchazi

Luvale peoples, northwestern
Zambia, 1997

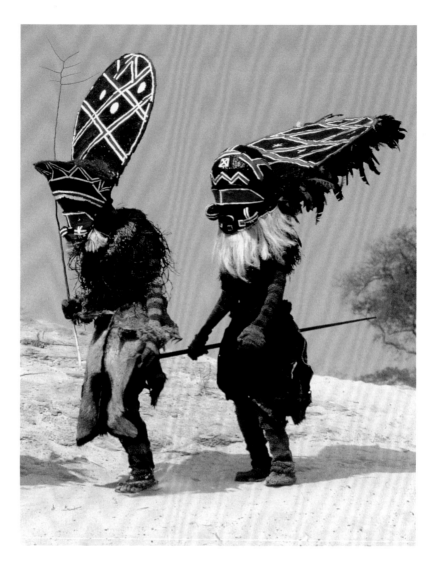

Description A *likishi*, or mask character, easily mistaken as Mupala (right; see 3.16) is instead identified as Litotola (also known as Katotola; left) solely on the basis of the additional small arched element atop the forehead in front of the larger arch. Litotola may also lack the feathers that are typically present on the back of the Mupala mask. Instead, a small keel-shaped structure may protrude perpendicularly from the back of the larger arch on the Litotola mask. The rear of the headdress may also be painted with designs or divided down the middle into contrasting fields of red and white pigmentation.

Attributes Mupala and Litotola are closely related masks and are built in similar fashion. The behavior, dance, attributes, and symbolic associations of these *makishi*, or mask characters, are also very similar, and the names are actually interchangeable in some areas. Where character distinctions are made, however, Litotola is considered a cousin of Mupala. Although the Luchazi also create this character, Litotola is primarily associated with the Luvale/Lwena peoples.

3.18

Character
Mwendumba

Type
Aggressive

Peoples
Chokwe, Luvale, Luchazi, Lunda, Mbunda

Lunda peoples, northwestern
Zambia, 1991

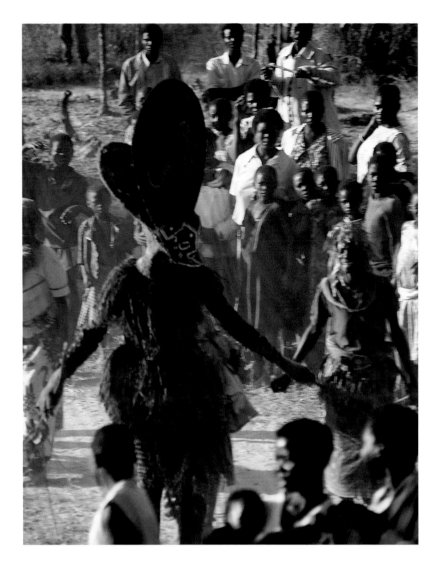

Description A double-arched headdress crowns the anthropomorphic face of the mask character known as Mwendumba. The arch in the front of the headdress is larger than the one that parallels it at the back. The headdress is the same shape but much smaller than that of Mupala (see 3.16) and Litotola or Katotola (see 3.17). The headdress is covered with decorative or symbolic patterns. The mask performer wears a full-body, knitted, fiber or cotton costume and generally an animal pelt as a skirt. Mwendumba may hold a branch or a weapon.

Attributes Mwendumba is another aggressive character thought to be auspicious for *mukanda* initiation, but this *likishi*, or mask character, appears in other contexts as well. Although identified as "the lion," Mwendumba has little in common with other animal characters (including another version of a lion), which are treated here as a subgroup of sociable mask characters (see 3.11, 3.12). In the case of Mwendumba, the epithet serves as an indication of strength or power, and the *likishi* behaves and performs in a manner resembling other aggressive characters. Most people, however, consider Mwendumba junior to other aggressive masks, and it is smaller than others in the aggressive category. This character is made by all the related peoples under consideration, but it is viewed by some to be a Chokwe mask.

3.19

Character
Kalelwa

Type
Aggressive

Peoples
Chokwe, Luvale, Luchazi, Lunda, Mbunda

Chokwe peoples, northwestern Zambia, 2006

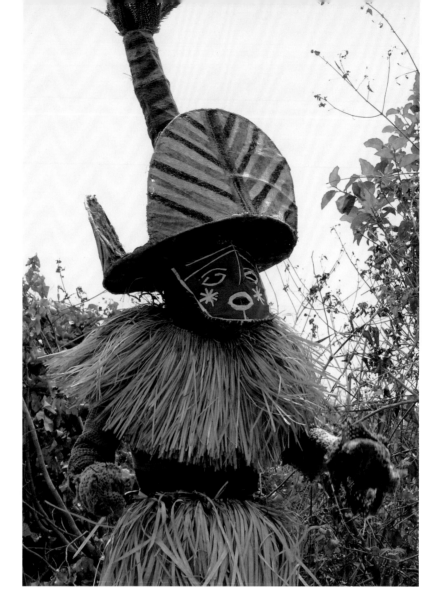

Description Kalelwa has an anthropomorphic face with a large headdress that is made in different styles. A tubular element extends from the middle of the top of the head with curved extensions or arched wing-like structures around it. Patterns or motifs decorate the headdress. The mask is normally made from ephemeral materials, and the costume includes a fiber or animal-pelt skirt. Kalelwa may hold a tree branch, a machete, or another weapon.

Attributes Kalelwa, a mask character endowed with physical and supernatural power, is primarily associated with *mukanda* initiation and is considered a protective spirit in terms of the camp and its initiates. While Kalelwa is numbered among those aggressive mask characters who chase women and uninitiated males while brandishing weapons, it is also one of the few who may symbolically assist women in the preparation of alcoholic beverages, an activity that takes place toward the conclusion of *mukanda* initiations. Although a bit more emphatic, the dance of Kalelwa is similar to that of Chikuza (see 3.20). Both of these *makishi* are generally agreed to be of Chokwe origin, but they are commonly made by all the related peoples of western and northwestern Zambia.

3.20

Character
Chikuza, Chikunza

Type
Aggressive

Peoples
**Chokwe, Luvale, Luchazi,
Lunda, Mbunda**

Chokwe peoples, northwestern
Zambia, 1991

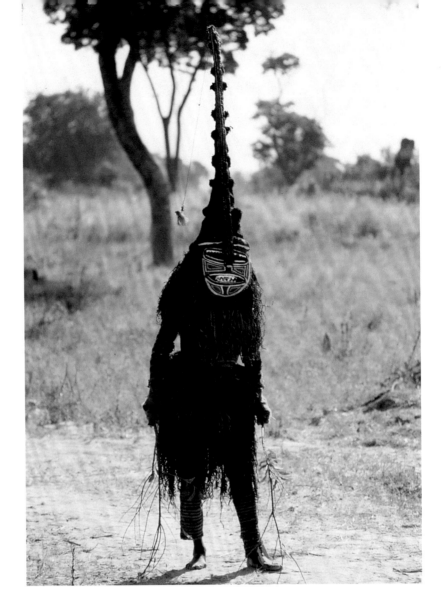

Description The face of Chikuza (also known as Chikunza) has anthropomorphic details, but the head extends to form a very tall and slightly curved conical shape resembling the horn of an antelope encircled with rings. This mask is normally made from ephemeral materials, and the performer wears a fiber skirt and neck covering. Chikuza may hold a bell, a tree branch, an axe, or another weapon.

Attributes Chikuza is symbolically associated with fertility and success in hunting. Although considered auspicious to *mukanda* initiation, this mask character may also be present at ceremonial events and other occasions. Although Chikuza may chase women and the uninitiated with weapons, it is probably the most relaxed of all the aggressive mask characters. In dance Chikuza plants its feet apart, placing them firmly on the ground, and twirls its hips to create a fanning motion of the skirt. This dance is interpreted as stressing the fertility associated with Chikuza.

3.21

Character
Utenu

Type
Aggressive

Peoples
Chokwe, Luvale, Luchazi, Lunda, Mbunda

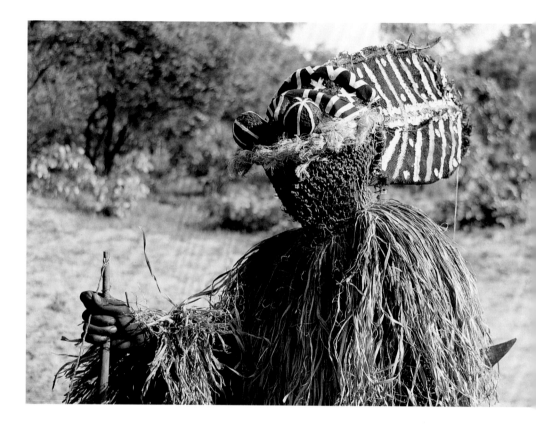

Lunda peoples, northwestern
Zambia, 1992

Description Utenu has an anthropomorphic face with a flat, keel-shaped headdress decorated with a variety of patterns. The character wears a full-body, knitted, fiber or cotton costume and usually an animal-pelt skirt. A machete is the preferred weapon of Utenu.

Attributes This *likishi*, or mask character, is considered junior to other aggressive masks such as Mupala (see 3.16) and Kalelwa (see 3.19). Utenu is extremely aggressive in chasing people and frequently casts insults and makes rude utterances. Utenu is called "the angry one," and the word *kazaye*, meaning "I am angry," is sometimes written on the character's headdress (see Jordán 1993). The dance performed by Utenu is similar to that of other aggressive mask characters, only more violent. Utenu sometimes runs and crashes on bushes or shrubs in a demonstration of uncontrollable rage.

Royal Characters

3.22

Character
Kayipu, Kahipu

Type
Royal

Peoples
Luvale

Luvale peoples, northwestern
Zambia, 1997

Description A huge arched headdress with decorative or symbolic designs on the front and feathers covering the back is characteristic of the royal character Kayipu (also known as Kahipu). The mask of Kayipu is made from ephemeral materials and characteristically has an anthropomorphic face with an exaggerated mouth, nose, eyes, and cheeks. These features are often highlighted in red. A white feather, a figurine, or a small decorative panel protrudes from the top of the head in front of the headdress. The performer wears a full-body, knitted, fiber or cotton costume and a blanket or printed textile as a skirt. Kayipu holds a spear or knife/sword (*mukwale*), which is used for animal sacrifice.

Attributes "King" of all mask characters, Kayipu is thought to have unsurpassed physical and supernatural powers. Kayipu masks, which represent aspects of Luvale royal ancestry, are kept only by senior or paramount chiefs. They are performed in the context of royal confirmatory ceremonies and funerals. Kayipu leads the procession of mask characters into the palace of the chief during annual ceremonies and sits on a throne in front of an audience composed of other *makishi,* or mask characters. Kayipu is not accessible to people, and either the mask itself or an assistant mask may physically punish anyone who gets too close. Anyone who approaches the character in an inappropriate manner may also suffer severe legal consequences. This particular mask does not generally occur in the context of *mukanda* initiations.

3.23

Character
Kateya

Type
Royal

Peoples
Mbunda

Mbunda peoples, northwestern
Zambia, 1997

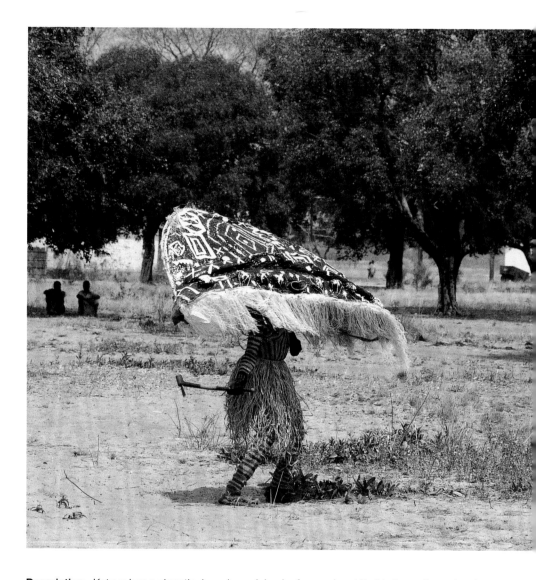

Description Kateya has a gigantic, broad, semicircular face or head that is three dimensional and fully covered with decorative or symbolic motifs. The mask is made from ephemeral materials, and its eyes, nose, large mouth, and multiple cheeks are defined in relief at the flat bottom edge of the semicircular head. A fiber beard is also attached at the bottom edge of the mask. The back of Kateya's head is covered with feathers. The performer wears a full-body, knitted, fiber or cotton costume and a skirt made of fibers. This mask character holds an axe or an adze as a weapon.

Attributes Much like Kayipu (see 3.22), Kateya represents an Mbunda royal ancestral spirit with extraordinary physical and supernatural powers. The character may perform as a royal Mbunda emissary during confirmatory ceremonies for paramount Luvale chiefs, since the Zambian Mbunda do not have chiefs of equal political bearing. This mask, like Kayipu, requires separation from spectators. It does not dance and remains at a visible distance from Luvale masks and people. It does not generally appear in the context of *mukanda* initiation.

3.24

Character
Kapalu

Type
Royal assistant

Peoples
Luvale

Luvale peoples, northwestern
Zambia, 1997

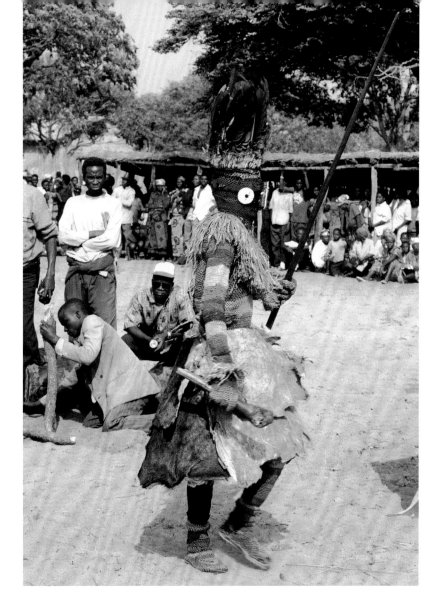

Description The face of Kapalu is made of knitted fiber or cotton with large attached eyes, one red and one white, and a distinctive headdress of feathers bunched within a round fiber frame. The performer wears a full-body, knitted, fiber or cotton costume and animal pelts instead of shorts or a fiber skirt. Kapalu typically holds a long spear or a stick as a weapon.

Attributes Kapalu serves as an assistant to Kayipu (see 3.22), controlling crowds during ceremonies by threatening them with a spear. This *likishi*, or mask character, also asks for money from spectators and may openly collect any minor objects (hats, sunglasses, drinks, etc.) that it covets. The mask may symbolically represent a form of "legal" authority and often assists Kayipu in sacrificing a goat during ceremonies—a sacrifice intended to honor the chief and to celebrate the ominous powers that the ruler and Kayipu share.

References Cited

Barbosa, Adriano
1989 *Dicionário Cokwe-Português*. Coimbra, Portugal: Instituto de Antropo-
 logia, Universidade de Coimbra.

Bastin, Marie-Louise
1982 *La sculpture tshokwe*. Meudon, France: Alain et Françoise Chaffin.
1998 "Chokwe Arts: Wealth of Symbolism and Aesthetic Expression." In
 Chokwe! Art and Initiation among Chokwe and Related Peoples,
 edited by Manuel Jordán, 13–19. Munich: Prestel for the Birmingham
 Museum of Art.

Batulukisi, Niangi
1998 "*Ngidi* and *Mukanda* Initiation Rites: Forces of Social Cohesion among
 the Holo." In *Chokwe! Art and Initiation among Chokwe and Related
 Peoples*, edited by Manuel Jordán, 85–91. Munich: Prestel for the
 Birmingham Museum of Art.

Burgeoise, Arthur
1984 *Art of the Yaka and Suku*. Meudon, France: Alain et Françoise Chaffin.

Cameron, Elisabeth L.
1998a "Potential and Fulfilled Woman: Initiations, Sculpture, and Masquer-
 ades in Kabompo District, Zambia." In *Chokwe! Art and Initiation
 among Chokwe and Related Peoples*, edited by Manuel Jordán,
 77–83. Munich: Prestel for the Birmingham Museum of Art.
1998b "Women=Masks: Initiation Arts in North-Western Province, Zambia."
 African Arts 31, no. 2 (spring): 50–61.
2001 *Art of the Lega*. Los Angeles: UCLA Fowler Museum of Cultural History.

Cole, Herbert M.
1970 *African Arts of Transformation*. Santa Barbara: Art Galleries of the
 University of California at Santa Barbara.
1985 "Introduction: The Mask, Masking, and Masquerade Arts in Africa."
 In *I Am Not Myself: The Art of African Masquerade*, edited by Herbert
 M. Cole, 15–27. Los Angeles: Museum of Cultural History, University
 of California, Los Angeles.

Felix, Marc Leo, and Manuel Jordán
1998 *Makishi lya Zambia: Mask Characters of the Upper Zambezi Peoples*.
 Munich: Fred Jahn.

Fisher, M. K.
1984 *Lunda-Ndembu Dictionary*. Ikelenge, Zambia: Lunda-Ndembu
 Publications.

Griaule, Marcel
1970 *Conversations with Ogotemmeli: An Introduction to Dogon Religious
 Ideas*. London: Oxford University Press.

Hambly, Wilfrid D.
1934 *The Ovimbundu of Angola*. Chicago: Field Museum of Natural History.

Heusch, Luc de
1972/1982 *Le roi ivre; ou, L'origine de l'état*. Paris: Gallimard. Translated in
 1982 by Roy G. Willis as *The Drunken King: or, The Origin of the State*.
 Bloomington: Indiana University Press.

Horton, A. E.
1990 *A Dictionary of Luvale*. El Monte, Calif.: Rahn Brothers.

Jordán, Manuel
1993 "Le masque comme processus ironique: Les *makishi* du nord-ouest
 de la Zambie." *Anthropologie et sociétés* 17, no. 3: 41–46.
1996 "Tossing Life in a Basket: Art and Divination among Chokwe, Lunda,
 Luvale, and Related Peoples of Northwestern Zambia." Ph.D. diss.,
 University of Iowa.
1998 "Engaging the Ancestors: *Makishi* Masquerades and the Transmission
 of Knowledge among Chokwe and Related Peoples." In *Chokwe! Art
 and Initiation among Chokwe and Related Peoples*, edited by Manuel
 Jordán, 66–75. Munich: Prestel for the Birmingham Museum of Art.

Kubik, Gerhard
1993 *Makisi, Nyau, Mapiko*. Munich: Trickster Publications.

Layton, Robert
1981 *The Anthropology of Art*. New York: Columbia University Press.

Lévi-Strauss, Claude
1982 *The Way of the Masks*. Translated by Sylvia Modelski. Seattle: Univer-
 sity of Washington Press.

Morris, William, ed.
1969 *The American Heritage Dictionary of the English Language*. Boston:
 Houghton Mifflin.

Napier, David
1986 *Masks, Transformation, and Paradox*. Berkeley: University of California
 Press.

Nooter, Mary, ed.
1993 *Secrecy: African Art that Conceals and Reveals*. Munich: Prestel for
 the Museum for African Art, New York.

Picton, John
1990 "What's in a Mask." *African Languages and Cultures* 3, no. 2: 181–202.

Roberts, Allen F.
1986 "Social and Historical Contexts of Tabwa Art." In *The Rising of a New
 Moon: A Century of Tabwa Art*, edited by E. Maurer and A. Roberts,
 1–48. Seattle: University of Washington Press for the University of
 Michigan Museum of Art, Ann Arbor.
1990 "Tabwa Masks: An Old Trick of the Human Race." *African Arts* 23, no.
 2 (April): 36–47, 101–3.

Roberts, Mary Nooter, and Allen F. Roberts
1996 *Memory: Luba Art and the Making of History*. Munich: Prestel for the
 Museum for African Art, New York.

Sieber, Roy,
1962 "Masks as Agents of Social Control." *African Studies Bulletin* 5, no. 2:
 8–13.

Strother, Zoe S.
1998 *Inventing Masks: Agency and History in the Art of the Central Pende*.
 Chicago: University of Chicago Press.

Turner, Victor
1982 *The Forest of Symbols: Aspects of Ndembu Ritual*. 2nd ed. Ithaca:
 Cornell University Press.

Vansina, Jan
1984 *Art History in Africa*. New York: Longman.

Wele, Patrick
1993 *Likumbi lya Mize and Other Luvale Traditional Ceremonies*. Lusaka:
 Zambia Educational Publishing House.

White, C. M. N.
1953 "Notes on the Circumcision Rites of the Balovale Tribes." *African
 Studies* 12, no. 2: 41–56.
1969 *Elements in Luvale Beliefs and Rituals*. Rhodes-Livingstone Papers,
 no. 32. Manchester: Manchester University Press for the Rhodes-
 Livingstone Institute.

Index

About the Author

A leading authority on the arts and cultures of Angolan and Zambian peoples, Manuel Jordán has been the Phyllis Wattis Curator of the Arts of Africa, Oceania, and the Americas at the Iris & B. Gerald Cantor Center for Visual Arts at Stanford University since 2001. He first conducted fieldwork in northwestern Zambia (as an affiliate of the Institute for African Studies of the University of Zambia) from 1991 to 1993 in the course of pursuing his graduate studies in art history at the University of Iowa. He received his doctorate in 1996 with a dissertation entitled "Tossing Life in a Basket: Art and Divination among Chokwe, Lunda, Luvale, and Related Peoples of Northwestern Zambia."

Jordán again traveled to Zambia in 1997 to conduct fieldwork in preparation for the exhibition *Chokwe! Art and Initiation among Chokwe and Related Peoples*, which he organized in 1998 as curator of the arts of Africa and the Americas at the Birmingham Museum of Art. He also edited a widely acclaimed volume of essays to accompany this exhibition. Jordán's other publications include *Makishi lya Zambia: Mask Characters of the Upper Zambezi Peoples*, with Marc Leo Felix (1998), and *Ngombo: Divination Arts of Central Africa* (2002). Following field research undertaken in 2004 and 2006, he has extended the focus of his research to include cultures of northern Zambia (Bisa, Lungu, and Tabwa) and Botswana's Yei, Mbukush, and Herero peoples.

Fowler Museum at UCLA